Paul Sher
3264 SW Fairmount Blvd
Portland Oregon 97239
503-248-9870 sherpohsu@aol.com

D0034240

Go Wild ...
With Your Camcorder
- How to Make Wildlife Films -

Go Wild ...
With Your Camcorder
- How to Make Wildlife Films -

Piers Warren

Published by

Wildeye
United Kingdom

Email: info@wildeye.co.uk
Websites: www.wildeye.co.uk/publishing
 www.wildeye.co.uk/wildlife-films

Copyright © Piers Warren 2006
First published 2006

ISBN 978-0-9541899-6-9

In memory of
Nick Gordon
Wildlife Film-maker
1952–2004

Acknowledgments

Many thanks to Roland Clare for copy-editing, Jeffery Boswall for information, Kelly John and the staff from *Wildlife & Countryside* magazine, Sally Saunders, Daniel Page and the staff at Lightning Source.

Also many thanks to the Wildeye tutors: Madelaine Westwood, Mike Linley, Caroline Brett, Alan Miller, Julian Wheeler, Malcolm Penny, Chris Watson, Simon Beer, Dave Knott, Warren Samuels, Rob and Sarah O'Meara, Sasha Kamen, Paul Kirui, John Parmasau, Kip Halsey, Captain Suresh Sharma, Neil Das, Sally Capper, Isaya Chaquet, James Laizer, Nan Swannie, Darwin Garcia, Doc Samuel Gruber, Sune Nightingale, Lindsey Dryden, Dan Nussey, Simon Christopher and all the Scubazoo staff, and all the helpers – too numerous to mention.

Thanks also to Steve and Barbara Bealey at the Norfolk Wildlife Centre, Kevin, John, Maggie, Vicky and Paulette at Whitwell Hall Country Centre, Karen Barber for her work on wildlife-film.com, Julian Matthews and Chris Johnston at Discovery Initiatives.

And of course a huge thanks to all the Wildeye students over the years who have made the journey worthwhile.

Contents

Introduction

Welcome to the wonderful world of wildlife film-making! Whether you want to film wildlife with your camcorder as a fascinating hobby, or are hoping for a career as a professional wildlife film-maker, this book aims to give you a good start. We will be exploring all aspects of recording wildlife with a camcorder; from choosing equipment to shooting techniques, fieldcraft, documentary themes and post-production.

Making wildlife films ticks many boxes – it gets you out in the fresh air, is a creative pastime, helps you to understand animal behaviour and the natural environment, and involves you in documenting a wild world that is changing increasingly rapidly. For those who fear technology, modern camcorders are easy to use – pick-up-and-shoot, for those who love gadgets there is a plethora available, and for those who relish a challenge, wildlife film-making presents many.

While watching wildlife programmes on television you may marvel at the stunning images, and wonder how the sequences are captured and woven into the finished film. With a little background information and guidance, which this book will deliver, there is no better way to find out how films are made than to try it yourself. It is true that many of the programmes you will have grown up watching are made by skilled crews with many years of experience, but it is also true that newcomers are producing some superb results.

Use this book as a primer – but continue your education by carefully watching and analysing the wildlife films you wish to emulate. There are also a number of specialist courses available to help develop your skills further – information about these can be found in the *Further Resources* section towards the end of the book.

The unusual thing about the wildlife film-making industry is that although some programmes are made by a large team of

specialists spread all over the world (such as the big series from the BBC Natural History Unit), it is also true that some wildlife films are produced entirely by one person with little more than a camcorder. Not that anyone can do it – filming wildlife takes dedication, patience and skill as well as a huge amount of luck! Having said that, if you have a yearning to capture wildlife images, whether it be a butterfly in your garden, a badger in the nearby wood, or hermit crabs on your holiday-beach, then all you need is a camcorder and a little patience.

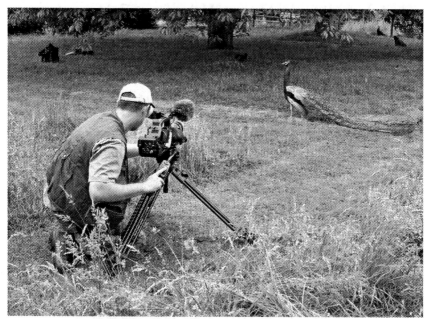

A wildlife park can be a great place to practice using your camcorder to film wildlife

This is a great time to be starting in film-making – you can get a basic camcorder for just a few hundred pounds (or even less – second-hand on eBay for example) and these days most personal computers come with built in video-editing software. Only a few years ago you would have been looking at spending tens of thousands of pounds on a 16mm film camera (photographic rather than video), more thousands on lenses, and then would have had to hire an editing studio for hundreds of pounds a day with all the associated pressure of paying per minute!

Furthermore your equipment would have been so big and heavy you would have needed an assistant to help you carry it all.

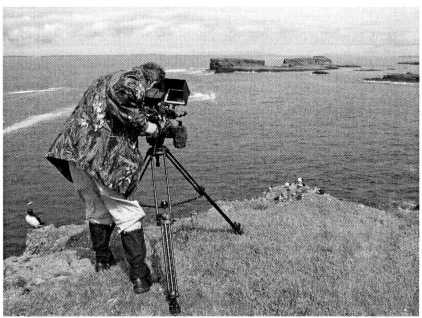

Although this camcorder has many extra gadgets attached, the whole set-up can be carried easily by one person. Here it is being used to film puffins on the Treshnish Isles off the West coast of Scotland

These days you have all the tools affordably at your finger tips – you just need to learn how to use those tools properly and creatively. The next chapter starts by discussing the only essential item – a camcorder!

Selecting a Camcorder

I am often asked what sort of camera is best to shoot wildlife – as if it needs to be significantly different from your average camcorder – but of course any camera will do to make a start. One of my cameras that gets a lot of use is a bottom-of-the-range, single CCD chip, miniDV camcorder. The reason it gets a lot of use is that it is small, lightweight and cheap – so it goes everywhere with me – in the car, in a rucksack, on a plane etc. Therefore it is always available when the unexpected happens (and with wildlife it often is unexpected) such as a flock of geese passing overhead, coming across a deer in a field and so on. As it is a relatively cheap camcorder I am less concerned about it being stolen or damaged, yet I still get good DV (digital video) quality.

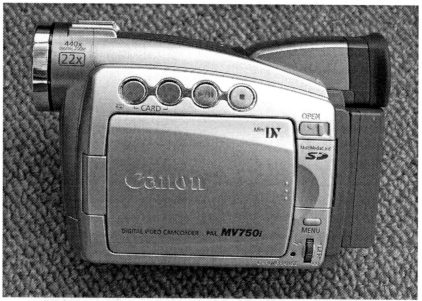

A single CCD chip miniDV camcorder. This Canon MV750i is particularly good for wildlife as it has a 22x optical zoom

If you already have a camcorder – then that's the one to use! You can still make films with analogue camcorders with formats such

as 8 mm, Hi8, VHS and S-VHS although the picture quality won't be as good as modern digital camcorders.

If you are looking to upgrade, or to buy your first camcorder with wildlife filming in mind, then there are a few considerations to explore. The first is what your intention is. If it is just to record wildlife for your own interest and to show friends, then any format is fine. If you wish to make mini-movies to go on the Internet or on CD-ROM/DVD then you will be looking at DV ideally. If you wish to shoot higher-quality footage for possible use on television, or to attract the interest of a production company/broadcaster, then you want to aim for at least three CCD chip DV or DVCAM or higher.

Before we get too far let's explore a few of these acronyms:

- **DV** stands for Digital Video (recording digits rather than a continuously changing signal with older *analogue* video camcorders). *DV* covers *all* digital video cameras.

- **MiniDV** refers to the small digital video tape cassettes used in miniDV camcorders – by far the most popular format currently.

- **CCD** stands for Charge-Coupled Device and is the chip used to capture picture information. Budget camcorders have just one chip, but more expensive three chip cameras split the colours into red, green and blue with a chip for each and have a higher quality picture as a result.

- **DVCAM** is a system that records on to tapes running at a slightly higher speed than normal DV (a 60 minute miniDV tape will run through in 40 minutes). This results in a slightly higher picture quality, although many people are hard pressed to notice the difference.

**A Sony 3-CCD camcorder being used to film a
Russell's viper drinking from a puddle in India**

Your budget may well be the deciding factor (isn't it always?). If
you can't spend more than a few hundred pounds then you will
probably be aiming at a single-chip DV camcorder – there are
many available now, some basic ones for little more than £200
new (see www.amazon.co.uk or Argos for great prices, or eBay as
mentioned). The vast majority currently record on to miniDV
tapes, but there are some that record on to other formats such as
DVD, Digital-8, HDD (direct on to hard disc drive – file-based
recording), DVCAM and HDV (High Definition Video).

If you can afford more than a few hundred pounds then you can
start looking at three-chip camcorders, and if you can approach
£2,500 then consider the Canon XL2. I mention this one by
name because the Canon XL series of camcorders has been
favourites with wildlife film-makers the world over (amateur,
semi-pro and some professionals). It superseded the Canon
XL1s which is a very popular camera and can now be obtained
second-hand at great prices (prices are coming down all the time
so those quoted in this book are just a guide at the time of
publication).

**Here a variety of camcorders are being used
to film a rat snake in India**

At this point I should point out that many of the wildlife films you see on television have been shot with either Super 16mm film, or a high quality video format such as Digital Betacam (Digibeta) or High Definition (HD). But these are expensive formats beyond the reach of many amateurs and (some) independents. Footage is key however (i.e. the importance of the subject you have filmed) and increasingly formats such as miniDV (especially three-chip quality) are being used in television programmes. The Canon XL cameras have a lot going for the wildlife specialist – above all the ability to change lenses, and with the right adaptor you can use the same inexpensive lenses as your SLR stills camera uses.

- **Super 16mm** film was the preferred format for wildlife films for television for many years. The cameras were small enough to carry through the jungle (though by no means lightweight) and the picture quality was superb with rich, smooth colouration. The 'Super' refers to the increased width of the recorded picture – filming in

widescreen (16:9 screen ratio (length:height) as opposed to normal 4:3). One major disadvantage of using photographic film, however, was being unable to see your results in the field – you could waste months deep in the jungle filming on fogged film stock for example.

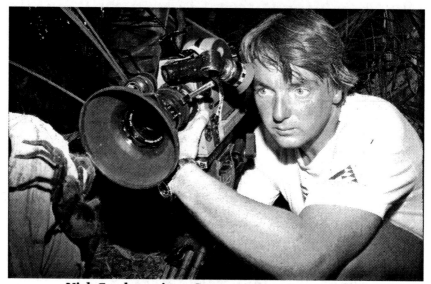

Nick Gordon using a Super 16mm camera to film Tarantulas in the Amazon

These days the majority of films for television are shot in widescreen ('future-proofing' your footage as the idea is that in the future we all have widescreen TVs – films made now in the old 4:3 ratio are less likely to be broadcast in the future) so that may be a consideration when choosing your camera. It is also worth mentioning that broadcasters will increasingly consider only films shot in High Definition (future-proofing again) so if you are aiming to make films for television you may decide to invest in an HD capable camera.

HD prices have come down rapidly recently and one option to consider is the Canon XLH1 for around £5,000 which again has interchangeable lenses. There are also HD camcorders from other manufacturers such as Sony (Z1 or FX1 for example) and JVC (GR-HD1), many more, some significantly cheaper, are

following. HD cameras recording on miniDV tapes are often called HDV camcorders.

The Canon XLH1

- **High Definition** (now don't worry if this bit gets too technical) relates to the number of pixels (the many tiny dots that make up the representation of a picture on the screen); the higher the number of pixels, the sharper the picture. Standard Definition (SD – most TVs in current use) provides 625 lines per frame (actually 576 visible lines, the rest being used for other information such as sync data and captioning) with the PAL system (used in the UK and many other countries) or 525 lines per frame (480 visible lines) with the NTSC system used in the USA and parts of South America (there are other standards as you'll see in the summary on the next page).

 High definition however provides increased resolutions of either 1080 or 720 lines per frame. To appreciate this improved picture quality, though, the film must not only have been shot on an HD camera, but have been edited on an HD system, broadcast in HD and viewed on an HDTV (High Definition Television). Japan is way ahead in this respect, with the US catching up and the UK and other countries snapping at their heels. Before too long all programmes will be broadcast in HD and to get the full benefit many of us will be buying new widescreen HD TVs.

Standards Summary			
PAL	**NTSC**	**SECAM**	**PAL-M**
625 lines/50Hz	525 lines/60Hz	625 lines/50Hz	525 lines/60Hz
Europe, Africa, China, Australia, India	Japan, USA, Canada, parts of South America	France, Central Africa, Middle East, Russia	Most of Brazil

Note that when you buy a camcorder (or pre-recorded video tape) it will conform to one of these standards. So a PAL camcorder will not work with NTSC equipment such as your TV for example. Be especially careful when buying equipment mail-order via the Internet that it conforms to the appropriate standard for your region.

When you are filming wildlife you are often up-close and personal (a butterfly on a flower, snails on your cabbages, busy ants etc) and this is where any DV camcorder is superb – most will allow you to fill the frame with something the size of a snail – keep the lighting bright and it will record with good colour and focus.

The problem comes with the long-distance shots (birds on a cliff-top, fox-cubs playing in a field etc). Camcorders are often advertised with amazing zooms such as 440x – but this only refers to the digital magnification. *Digital* zooms will pixelate badly (the picture appears as tiny squares) so look out for a camcorder with a good *optical* zoom – 20x or more. Also make sure you set up your camera (in the menu) so that the digital zoom is not used – keep it optical!

Another important factor when choosing your camera is the ability to connect an external microphone and a pair of headphones. Wildlife sounds are extremely difficult to record, being either very quiet or a long way away, and so it is a great bonus to be able to use a separate microphone. This could be a microphone used close-up (e.g. next to a bird's nest) or for gathering long distance sound by using a highly directional microphone. Camcorder-based microphones are poor in both these situations, and pick up a certain amount of camera-noise.

Incidentally, it comes as a surprise to many people that most of the sound you hear on wildlife television programmes is not recorded live. Animal and atmospheric sounds are often added later from separate audio recordings made in the field or from sound libraries, with plenty of 'Foley' sound (splashing water in a bowl to accompany fish movements, or chewing celery into a microphone as the lion tucks into his zebra-lunch). More on this later.

If you wish to use your camcorder underwater then another consideration is which suitable waterproof housings are available. MiniDV camcorders are superb for underwater work as they are small and easy to operate – a common combination with programme-makers has been to use Sony miniDV camcorders with Light and Motion housings, although many other combinations are available. Check out options before you choose your camcorder as housings can be surprisingly expensive.

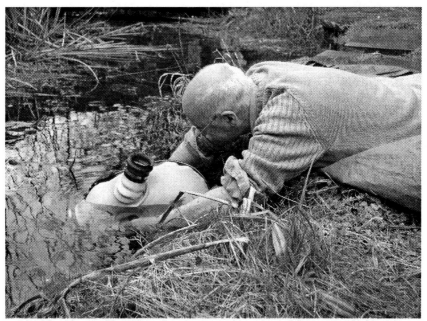

A rubber splashbag for the Canon XL1 – useful for shallow water filming but nothing more than a few metres deep. Here it is being used to film the wildlife in a pond, although it would be easier to control the camera if the operator was in the water as well

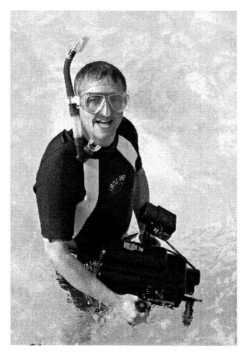

A Gates housing for the Canon XL1 can be used at greater depths.

In this case it is being used to film blacktip sharks in the Bahamas

Some camcorders available these days have infra-red capability which may be a consideration if you are planning some night-time filming – of badgers at a sett for example. These cameras usually have tiny infra-red lights around the lens which are not very strong and will illuminate only subjects up to a few metres away.

If you want to film something further away in the dark you can supplement this with stronger infra-red lights – for example you can use old car headlights with the glass covered by an infra-red film, powered by a car battery. A further option would be to buy a separate infra-red camera later if you needed it. These can be obtained through specialist camera suppliers or, once you know what you are looking for, through other avenues such as eBay (search for 'infra-red cameras' on eBay for example and you will be presented with hundreds of options).

Other Useful Equipment

I've watched countless wildlife films – both amateur and professional – and I have to say the one thing that immediately lets a shot down is when the camera is wobbling all over the place. Many people automatically stand up while using their camcorder and hold it up to eye level – but in this position it is practically impossible to keep the camera steady enough to give you an impressive result. Kneeling or lying down will help stabilise your body and arms, but there are some simple bits of kit to add to your set-up that will drastically improve matters.

Support

The two most important accessories for a wildlife film-maker are a tripod and a beanbag. When choosing a tripod think about the weight of it: a heavy tripod will certainly be steadier, but can you carry it long distances and easily take it where your camcorder goes (on a plane for example)?

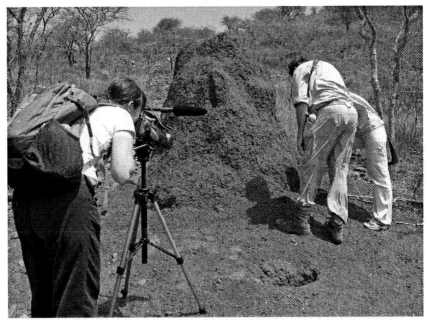

Here a medium weight tripod is used to support a Sony PD170 whilst filming termite mounds in Tanzania

One of the most important factors when selecting a tripod, however, is how smoothly the head moves when you pan (move from side to side) and tilt (move up and down) – fluid-heads are the best, and of course the most expensive! So try out tripods in a shop before you buy – preferably with your own camcorder – pan and tilt and check for any jarring or vibration. The one I use most often is lightweight and folds up really small, it doesn't have a fluid-head but is smooth – and that cost me less than £50 (although you can spend hundreds or even thousands on a good tripod). The main disadvantage is that with its lack of weight it will vibrate if conditions are windy – so then I take a heavier one – or improvise other support.

Monopods can also be extremely useful. They can be used in vehicles for example where there is no room to set up a tripod. If you do a lot of work from a vehicle – such as a Land Rover on safari – you may find a clamp system useful. It's basically the head of a tripod attached to a clamp which you can fasten to the bars or window ledge of the vehicle to keep your camera steady.

A clamp with a tripod head used to steady a Sony Z1 on the roof of a Land Rover whilst filming lions on safari in Kenya

A beanbag will be your best friend! It will steady your camcorder in many awkward situations – on a rock, the car window ledge, on a boat, on grass etc. It will also protect your camcorder from dirt and water. You can buy them ready-made or make your own using a soft waterproof material of a suitable size to support your camcorder. Fill the bag with something like rice that will not be too noisy as it moves around – do not overfill – you may need to experiment for a while until you get the right size and shape of beanbag but it's well worth the effort. If you are travelling abroad you can take the beanbag empty (to save on weight and volume) and fill with beans/sand etc when you arrive on location.

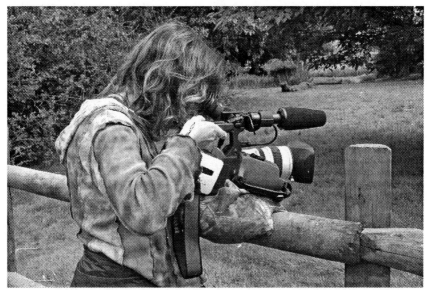
Using a bean bag on a fence to steady a Canon XL1s

Lenses

If your camcorder can take different lenses then this opens up lots of other possibilities. As well as your general zoom or telephoto lens you will be able to buy wide-angle lenses for scenic shots or use in enclosed places such as a creature's burrow, macro lenses for those stunning close-ups and so on. You will also be able to obtain attachments to connect your

camcorder to a microscope, or an endoscope for probing termite nests and the like.

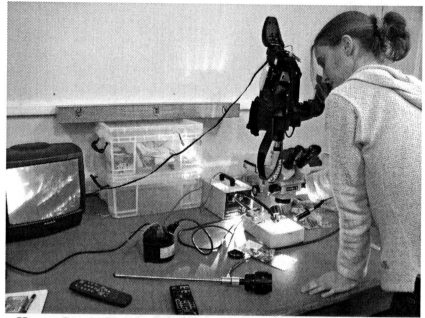

Here a Canon XL1s is attached to a microscope to film pond life. Note the camera is also attached to a TV monitor which can help locate the subjects to film and enable others to watch what is being filmed. It can also be less tiring than peering down the viewfinder for long periods

Some of these extras are also available for camcorders with fixed lenses – such as wide angle or telephoto attachments which fit on to the end of the camcorder's lens. For example you can get 2x or 3x teleconverters for many camcorders which simply double or triple the magnification of the image.

Lenses can be very expensive – in some cases more expensive than the camera – so do try before you buy. If you only needed a specific lens for a particular sequence in your film it might be better to borrow or hire a lens, or team up with another camcorder-user who has the right kit.

As mentioned already some camcorders, such as the Canon XL series, can take a variety of lenses with the right adaptors. So even if you have a number of Nikon, Sigma or Tamron lenses for your stills SLR camera for example, you can use these on a Canon XL with a Nikon adaptor.

Note that these lenses were designed for a 35mm film, but when used on your camcorder they will be focused on the smaller area of the CCD chip – 1/3 inch for example. The result is a higher magnification than you would expect (7.2x higher in this case, so a 100–300 zoom would give you the equivalent magnification of a 720–2,160 zoom on your SLR camera!). This is a great bonus when filming close-ups at a distance – but remember the higher the magnification the more stable the camcorder set-up needs to be to prevent image-wobble.

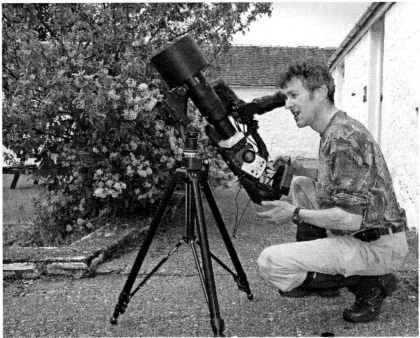

This huge lens attached to a Canon XL1s is a Sigma 800mm lens offering massive magnification and used here by Dave Knott to film the transit of Venus across the sun. Several filters were used to prevent the bright sun burning out the CCDs. Under normal circumstances do not point your camera directly at the sun!

Lights

You are most likely to want to use lights if you are filming indoors on a set or in a dark outdoor enclosed situation such as inside a burrow or nest box. There are many small lighting set ups designed specifically for filming available these days. Some are based on spotlights which provide intense light, but also create a lot of heat which can be dangerous for your subjects. Cool lighting based on fibre-optics has advanced greatly recently and will be a good addition to your kit – especially if you do a lot of macro work.

One of the great advantages of video over photographic film cameras is that they can record better pictures at much lower light levels – so there is no need for huge bright spotlights. If you are recording relatively close-up at night (frogs mating in a pond for example) you will find that a few torches will solve your lighting problems. Place these on the ground or a support rather than hand-hold them so the shadows don't wobble around.

You can get video lights that attach to the hot-shoe on the top of your camcorder – these are of limited use in wildlife situations as they illuminate only subjects a short distance from the lens, and also drain the battery faster. If you are working on a set you are better off with a couple of spotlights so that you can move them around to eliminate shadows and create the lighting effect you want. Don't always go for the obvious front-lit, few-shadows option – sometimes a subject lit from the side or back can produce a more dramatic shot. As in so many aspects of film-making with video the best way to learn is to experiment with different techniques, view your footage on a television, and make notes about which results you prefer.

Power

At the very least have two batteries for you camcorder – so one can be recharging while you use the other. If you will be in the field for long periods without access to a charger you will need several high capacity batteries or a battery belt (essentially a

number of batteries in series attached to a belt you wear around your waist and connect to the camcorder). Other bits of kit such as connections which allow you to recharge your camera batteries from a car battery (or via the cigarette lighter socket) can be very useful.

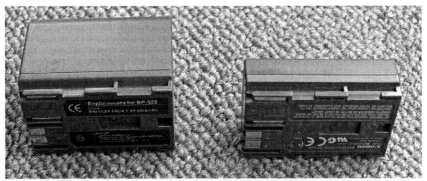

You can buy batteries of different capacities – the one on the right which came with the camera will last about 45 minutes in the field, the one on the left about 3 hours – much more suitable for situations where you may be far from a charger

Recording Media

If your camcorder takes miniDV tapes then you should get into the habit of using just one manufacturer of tape – whether JVC, Panasonic, Sony, TDK etc. This is because they have different lubricants which may clog your camera heads if you mix them.

Always record in Standard Play mode (SP), never in Long Play (LP). Long Play means the tape records more minutes per tape (usually 90 minutes on a 60 minute tape) but at a loss in quality. Tapes are so cheap these days it's just not worth it.

In time you may also need a head-cleaning tape for your camcorder. You usually run these in play mode for about ten seconds when needed. They work by wearing the head down a bit to clean it – so don't overuse them or you will wear the heads out altogether. Use them when you see digital distortion on the

recorded picture – this will appear as squares or blocks of lines across the image.

MiniDV tapes

MiniDV cleaning cassette

Sound

I have already mentioned the special challenges of recording wildlife sound, and if you are able to attach an external microphone to your camcorder I would suggest you invest in a few extra ones. The first would be a tie-clip microphone – these can be fairly inexpensive and can be used by a presenter or interviewee as well as for recording close-up animal sounds (in a nest, down a burrow etc). Remember it will also be a good idea to get extra-long leads for external microphones in these situations.

An inexpensive tie-clip microphone from Sony

Another microphone you will need is a directional one to pick up individual animal sounds. Some, such as shotgun-mikes (also known as *rifle* mikes) like the Sennheiser MKH 406, can be used on the camera, on a boom or tripod, or positioned on the ground or your beanbag. Alternatively you can use a microphone in a parabolic reflector which focuses sound from one direction (often used by people recording bird calls). You may need someone to help hold and aim this while you are filming.

A further microphone that would come in handy would be a stereo microphone (or a matching pair of mono microphones) that can be used for recording atmospheres. As any wildlife film editor will tell you, you can never have too many atmosphere recordings – more on that later.

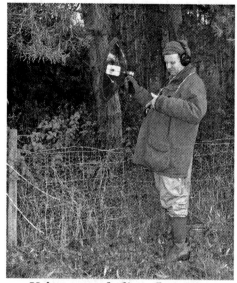

**Using a parabolic reflector to
record birds in a wood**

**The Sony ECM MS907 – an electret stereo microphone powered
by a battery that can be used for atmosphere recordings**

When you are choosing microphones, be aware that they differ both in their construction, and in their pickup pattern (also known as the polar response pattern). The most common types of construction are

- **Dynamic** – the microphone diaphragm moves a coil in a magnet when hit by sound waves producing a current. These are robust and affordable microphones that do not need power but need a relatively loud sound source to create a good signal – so not the best if the wildlife is very quiet or far away.

- **Electret** – these feature a lightly-charged diaphragm which creates a fluctuating capacitance as it vibrates with sound waves, producing a current. These are usually powered by a battery (such as a 1.5 volt AA battery in the handle of the microphone). These are more sensitive than dynamics and good for wildlife but bear in mind that that the diaphragm can lose its charge with time – so don't buy an old second hand one. Make sure the battery is delivering full power.

- **Condenser** – the same basic operation as electret microphones, but requiring a higher power of 48 volts. This power is often supplied from the camera (or recorder) via the microphone cable and is called *phantom powering*. Not all camcorders can deliver this so check before buying a condenser microphone for yours. These are very good sensitive microphones but usually the most expensive and delicate.

The main different pickup patterns are:

- **Cardioid** – or uni-directional – picking up sound principally from the front and some from the sides.

- **Hypercardioid** – even more directional, such as gunshot (or rifle) microphones – good for recording individual animals at a point source.

- **Figure of Eight** – picking up principally from two sides – can be used for interviews for example.

- **Omni** – picking up sounds from all directions – can be used for atmospheres.

A really useful extra piece of kit for your sound recording set-up is a windshield. Even the slightest breeze blowing across the front of a microphone will produce a low frequency roaring sound which can ruin a recording. The idea is to use a fluffy/hairy covering to break up the air current. There are various manufacturers of windshields – the best-known being Rycote – but any fluffy covering (such as soft-toy coverings) is better than nothing.

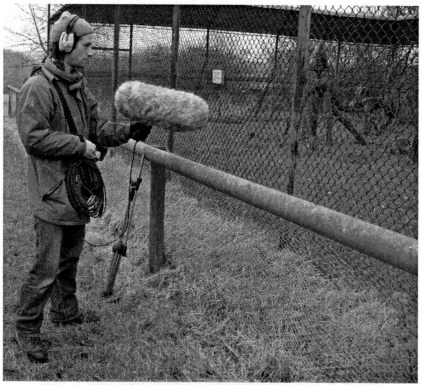

**Here a microphone with a windshield is used to record
Barbary apes chattering quietly in a wildlife park**

Some wildlife productions use a separate wildlife sound recordist and you may wish to team up with someone to do this. Another option is to record your wildlife sounds on a separate audio recorder rather than on your camcorder. This will save wear and tear on your camcorder as you may wish to record hours of audio atmospheres for later editing.

For some years the professional standard was to record on DAT (Digital Audio Tape) but this is gradually being superseded by digital file-based recorders. These are very good and likely to become the future standard, but are still quite expensive. Another option is to record on to a HiMD (Hi Mini Disc) recorder such as the Sony MZ-NH900. Unlike normal MD these can record audio uncompressed at CD quality. They are more affordable than file-based systems and small enough to slip into a pocket.

The Sony MZ-NH900 Hi Mini Disc recorder

You can use MP3 players that have a recording facility but the audio compression makes the quality of the recordings unsatisfactory.

You will find that some recorders and camcorders come with a mini-jack socket (3.5 mm diameter) for attaching microphones, but the preferred connectors are XLR sockets/plugs. These are larger and stronger and are 'balanced' which means any

electrical interference picked up by the microphone cable is cancelled out.

Much more advice and resources for recording sound can be had from the Wildlife Sound Recording Society (details in the Further Resources section at the end of the book).

This Canon XL1s is fitted with numerous extra bits of kit including a windshield for the microphone, XLR sockets for attaching microphones, a larger shoulder bracket which carries extra battery packs and a large monitor

Be neither heard nor seen

Finally you will need some accessories to make sure you can get close to the wildlife without scaring them away with your Day-Glo cagoule and noisy, shiny equipment. As far as noise goes, avoid Velcro, zips and noisy materials such as nylon. Also make sure there are no rattly bits on any gear, such as metal clips on straps (tape these with masking tape or duct/gaffa tape).

To avoid being seen you can use a portable hide and/or conceal yourself and your equipment with camouflaged coverings – coats, balaclavas, camera covers, tripod wraps etc. A whole range of useful accessories, including hides, camouflage tape and material, nets, clothing and so on is available from Wildlife Watching Supplies (details later). Of course you may also need to avoid being smelt by the wildlife you are trying to get close to – this is all part of 'fieldcraft' which we look at in more detail later.

Subjects for Filming

If you want to film wildlife as an amateur, or are hoping for a future career in the profession, then it is likely that your first subjects will be either the wildlife in your own garden, wildlife you encounter on holiday, or wildlife encountered as a result of a special trip with this aim in mind. Let's look at these three situations in more detail:

Garden Wildlife

There are lots of advantages to filming in your own backyard: all your equipment is at hand, there are no travel costs, you get to know your subjects through daily observation and so on. Even small city gardens can be host to a wide variety of interesting wildlife – from birds attracted to your bird table, to wasp nests to butterflies to hedgehogs. Even larger wild animals such as foxes are becoming more common in the urban garden. People with larger rural gardens may be lucky enough to encounter other photogenic creatures such as badgers, deer, weasels and many rodents.

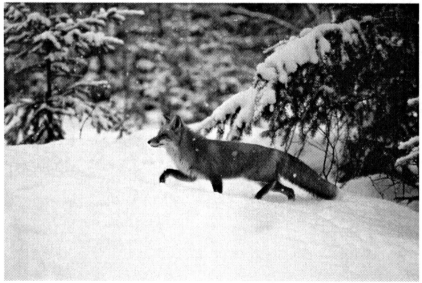

Your local fox may provide a good subject for your film

Watching the wildlife every day allows you not only to get to know your subjects – when they will appear, what they will do, which aspects you want to film and so on – but also to be at hand at all times of the year. This is the perfect way to film the life-cycle of certain animals without having to sit in a hide for twelve months (not guaranteed to impress your boss or your spouse). It also allows you to leave your camcorder set up in one position ready for any action – pointing at a bird's nest for example.

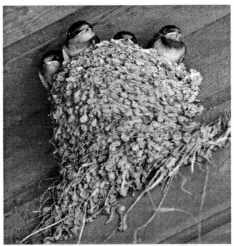

The building of a swallow's nest, and development of the young, can be filmed without having to move the camcorder

There are some great gadgets available these days that are perfect for the home wildlife videographer – such as tiny cameras that you can place in nest boxes attached to, or near, your house. A cable can then run the signal into your warm, dry, comfortable lounge or study, where you will sit with a cup of tea watching for action on a monitor or television. The tiny camera will be plugged into your camcorder (note: only some camcorders accept external signals), or a separate miniDV recorder (Sony do good ones with a flip-up screen that also saves your miniDV camera from excess wear when playing miniDV tapes, editing etc – the Sony GVD-1000E Mini DV Digital Video Walkman). When you see some action you want to record you

simply press the record button. Some of these tiny cameras even give you the capability to zoom, tilt and pan remotely.

This is just the sort of approach used in the nest box shots seen in programmes such as BBC's partly-live *Britain Goes Wild* and *Springwatch* series which have been hugely popular with the British public.

Holiday Wildlife

One of the most exciting aspects of going on holiday abroad can be the wildlife you encounter that you wouldn't find at home. Of course you won't be able to film any one subject for any length of time, so the best approach is to think in terms of a portrait of an area concentrating on the indigenous wildlife. Take your camcorder wherever you go – you never know when you will come across an interesting opportunity – geckos on a floodlit wall at night for example, or birds or monkeys scavenging around the restaurant tables. This is a situation where it helps to have a small lightweight camcorder that can slip into your pocket.

Top tips for the holiday wildlife film-maker are

- Take as many fully-charged batteries as you can afford – at least two.
- Check you have the right plug/adaptor (for that country) for your battery charger and that the voltage is compatible.
- Take plenty of tapes in case they cannot be bought locally.
- Check that your equipment is insured under your travel policy.
- Take a small, lightweight tripod and beanbag for support.
- Pack all your gear into a small, padded rucksack that is attached to you at all times (not into an obvious camera-bag that will be a top-target for thieves).

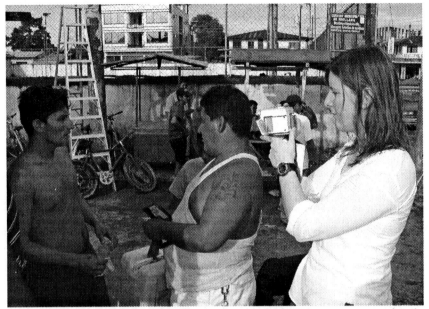

This small camcorder, identifying the user as an innocent tourist, is being used to film an illegal bushmeat market in Ecuador

Special Trips

Taking things a step further you may want to go on excursions especially to film certain wildlife. This could mean a trip down to the local river to film the kingfishers, or a full-blown wildlife safari. African safaris will certainly get you close to some big animals, but there are downsides too – you will spend most of your time in a hot vehicle with other people (some of whom you may not get on with, or who will be clicking away with their stills cameras while you are trying to film) looking at a few lions who will probably be asleep most of the time and be surrounded by other vehicles. Plus the footage you get is the sort you will be likely to have seen hundreds of times on television. So look for the more unusual safaris, or engage your own guide and give specific instructions as to what you would like to film.

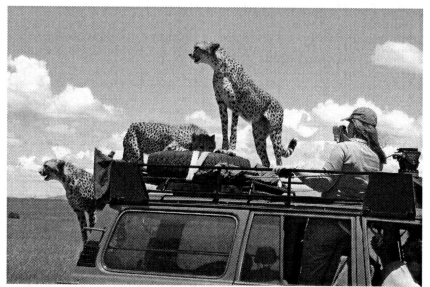

If you are very lucky you will find yourself in a position to get some extreme close-ups! Cheetahs are being filmed here in the Masai Mara, Kenya

The key to trips closer to home is to do your research first. It's all very well setting off to North Scotland with the aim of filming coastal otters – but if you haven't researched exactly where and when to find them you may have a wasted and frustrating trip. Local Wildlife Trusts may be able to help you with advice about which species can be found at their nature reserves. Habitats that are not far from where you live can be convenient for repeated trips – do not underestimate the amount of fascinating wildlife to be found at a nearby river, lake or woodland for example.

On this boat trip off the Scottish Isle of Mull
the rewards included shots of minke whales

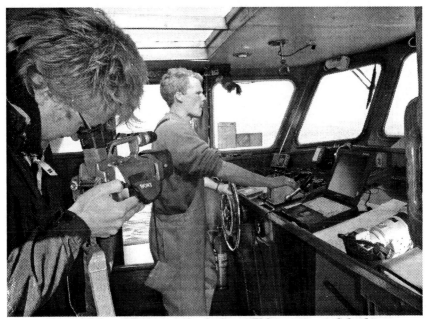

Shots of the skipper at the helm will be very useful when
constructing the story of the trip at the edit stage.

If you want to film something more unusual (or at least document the search for them) then why not aim for some of the more enigmatic creatures to be found such as wild boar or big cats (yes – even in Britain). There is growing evidence that there are numerous big cats living in the wild (escaped pumas, lynx etc) and finding them would not only make a great story, but if you actually got video footage of a big cat you would also find it very valuable!

Documentary Themes

If you are an opportunist you will end up with a series of brief clips of creatures that you have simply come across. Not that there's anything wrong with that, but many camcorder-users wish to create sequences that can be edited together to produce a finished piece that is more interesting to watch – a film with a story.

This certainly requires planning. If we look at how professional wildlife films are made the process can be split into four stages:

1. **Conception** – what will the film be about? Development of topic, style and storyline.

2. **Pre-production** – research of subject and location, budgeting, choose crew (you), plan the shooting-script (a list of the shots you ideally want to capture to tell the story).

3. **Production** – the actual acquisition of footage and sound on location.

4. **Post-production** – editing the footage and sound; including narration, music, titles and so on. Distribution – video copies, via the Internet, on CD-ROM/DVD etc.

As far as you're concerned the first stage will be deciding what and where you are going to shoot, and what the story will be. Some opportunities will present themselves to you – foxes building a den under your garden shed for example. Others can be created – perhaps by placing small cameras in bird nest boxes, enabling you to capture the life-cycle of whichever species takes up residence. Others will revolve around habitats – the wildlife that visits your pond for example.

Here are some classic ideas for wildlife film themes:

The Life-cycle of a Specific Animal – often covering twelve months. Examples: garden foxes or hedgehogs, birds nesting in a box or shed, insects such as butterflies, wasps (careful now), dragonflies (good opportunity to combine land shots with underwater shots of the larval stage – challenging), badgers in a nearby wood. This theme is most suitable for a back garden environment where you will be on hand throughout the year.

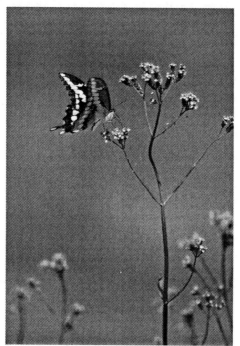

**The life-cycle of a swallowtail butterfly
could form the basis of your film**

An Individual – taking the above theme a step further you could even focus on one individual animal – let's say a fox that comes to your garden to feed every night. Give the animal a name if you wish and get the viewer involved in its life – add some drama: let's say it goes missing for a few days, or focus on how it finds a mate or rears its offspring.

A Year in a Habitat – can encompass a whole range of wildlife that inhabits a certain environment, and the changes seen throughout the year. Examples: a year in the life of your garden pond, a local forest or river, or try some more unusual habitats such as a year in the (wild)life of your local rubbish tip. You may wish to concentrate on the differences between the four seasons at that habitat and how the wildlife adapts to the changes.

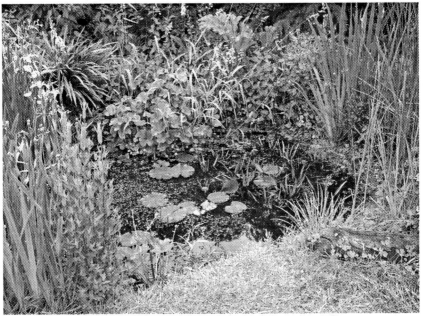

Your garden pond could provide a suitable habitat to film over a 12 month period

Dawn to Dusk – a day in the life of your garden, the pond, a nearby wood etc. As mentioned the great advantage of video over film here is that you can still get reasonable images with the low light levels at dawn and dusk without having to use artificial lighting. You'll have to get up early for part of this one, but you'll see a different range of wildlife than the daytime shift. If you do wish to use lighting to film during the night you can stretch this to the full 24 hours – but bear in mind that you may have to set up the night-lights some weeks in advance to let the wildlife become accustomed to them – or use infra-red technology.

A Natural Cycle – for example, if you live near the coast you could concentrate on the differences between high tide and low tide, and how the wildlife behaves as the tides turn.

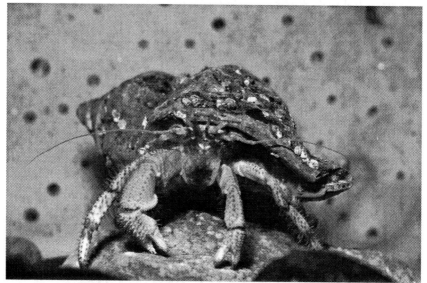

You could base your film on how the behaviour of animals such as this hermit crab is affected by the tides

An Expedition – this is an opportunity to involve yourself in the video, Benedict Allen style. Let's say for example that you are going to look for wild boar in a Suffolk wood. The film can start with your preparations and setting off on the journey and lead into arriving at the woodland and actually searching for the boar. If you are doing this with a friend then you can film each other, or have one of you as the camera operator throughout.

But even if you are alone you can add drama and a personal angle to the film by talking directly to the camera about what you are doing and how you are feeling. You can either set up the camcorder on a tripod to do this – to film yourself loading your gear into the car for example – or hold it at arm's length and point towards your face – say while you are walking along.

Remember to chat to the camcorder as if it is a single-person – a friend – look it in the eye (lens), lose all your inhibitions and just be yourself. Make a good story from the situation, add some suspense and you'll end up with a watchable film even if you never find the boar!

On Safari – if you are going on a holiday which includes lots of opportunity to film wildlife then you can base the film on the trip from start to finish. Involve yourself as above because some of the shots of your living conditions, the briefings, packing the vehicles etc will be as interesting as the wildlife you encounter. Make sure that you check beforehand with the staff that they are happy for you to record them talking and doing their job – adding the morning briefing from the safari camp staff is a great way to add some suspense to the film – will you really see a cheetah hunting later that day?

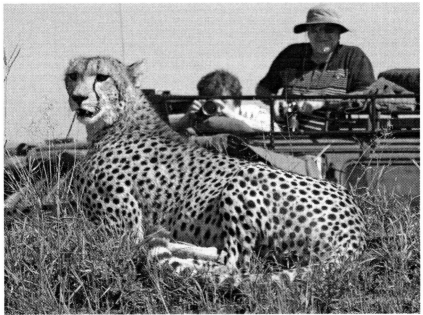

A safari holiday will certainly get you close enough to some stunning wildlife to get some great shots

Biological Topic – you may wish to base your film on a certain aspect of the life of an animal or range of animals. For example, you could focus on how animals find food, whether birds or caterpillars or squirrels, or how animals in your garden survive winter. How about a film about metamorphosis – comparing the differences between tadpoles turning into frogs with caterpillars turning into butterflies?

Scientists attaching a tag to a tiger shark in the Bahamas. This could form part of a film about the behaviour of sharks

A Project – another opportunity to involve people in your film is to concentrate on a wildlife-orientated project. A local bat group putting up bat boxes and searching for bats with their ultrasonic equipment, or a farmer putting up nest boxes for barn owls, can make interesting stories. Wildlife Trusts and groups from BTCV (British Trust for Conservation Volunteers) are often doing photogenic conservation work such as building walkways or clearing scrub – approach them to see what they are up to in your area – they may well be very happy to be filmed.

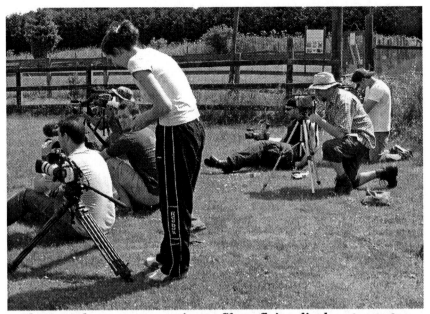

These students are preparing to film a flying display at a raptor centre. This could be supplemented with interviews with the handlers, close-ups of the birds and so on

Camera Techniques

One of the best ways to pick up good techniques for filming wildlife is to watch how the professionals do it on television. Make video/DVD recordings of a few programmes in a style you would like to emulate, and view them carefully several times, making notes on techniques you would like to copy. Pay attention to all aspects – the actual use of the camera, what wildlife footage is most memorable, how it was edited together to make a good story, what the narration adds etc. You will find few cinematic gimmicks in classic wildlife films so it's up to the skill of the camera operator (and later the editor) to shoot the footage that can be woven into exciting sequences.

As far as gadgets go you could spend a fortune on extras to help you take more interesting shots, but, as you'll see, a little bit of improvisation can solve a lot of problems more cheaply. Wildlife film-makers, often working in the bush far away from any studio or gadget-store, are well known for their improvisation!

Let's concentrate on a few of the most important aspects of camera technique:

Handling the camcorder – nearly all shots are supported by tripod or beanbag unless a lot of fast action is going on close to the camera operator (following a hopping frog for example, or keeping up with Steve Irwin). A good smooth tripod-head is essential for those smooth pans and tilts.

Many of the shots that make up a wildlife film, however, will be *locked-off* shots – i.e. those where the camera does not move at all. Another point is that when you press the record button – when you start and stop filming – it will jog the camera – so always wait a couple of seconds at the end of a shot before pressing the button to give enough room to end the shot nicely in the edit.

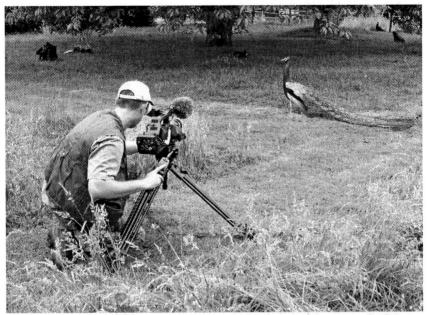

This tripod is being used to smoothly follow the peacock (by panning) as it walks past. Note the cameraman's right hand is on a remote control attached to the tripod – enabling him to control the record button and the zoom whilst moving the tripod head at the same time, leaving his left hand free to alter the focus

If you find yourself in a situation where you don't have a tripod or beanbag then make use of anything around you to stabilise the camera. Lean against a tree or on the roof of a vehicle or lie on the ground. In particular, if you are holding the camera while recording, you need to steady your elbows – keep them pulled in to your body, or kneel on one knee and rest your elbow on the other.

Don't forget that camera shake or movement will be greatly magnified as you zoom in on a subject. So if possible move closer to the subject rather than zooming in. If you are using a long telephoto lens even the tiniest vibration can ruin a shot and a sturdy tripod or other support will be essential.

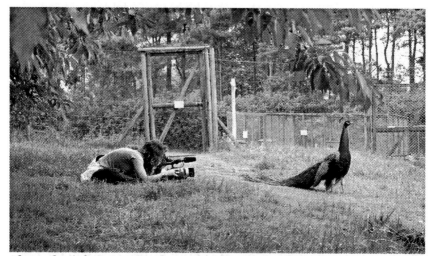

If you don't have a tripod, resting the camcorder on the ground will not only steady the shot, but produce a more pleasing picture than if it had been on a tripod looking down on the peacock

Viewfinders – most camcorders these days give you the option of using either the viewfinder (which may produce an image in colour or black and white) or a flip-out mini LCD screen.

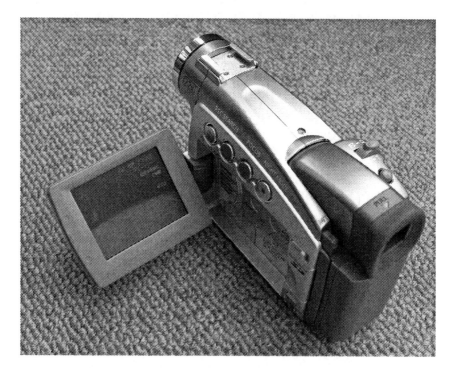

The LCD screen can be rotated to a position to suit the situation. Some camera operators who are used to using the viewfinders of film cameras, prefer to use them on video camcorders too, but use whichever you feel most comfortable with. In bright conditions you may find it hard to see the LCD screen, so revert to the viewfinder.

Focus – in general with wildlife (and this goes for stills too) it is best to focus on the eye of the animal. This is especially important with close-ups and macro work where you may be so close that only part of the subject can be in focus.

It is also recommended that you practise using manual focus as much as possible. If an animal moves off shot while you are filming it in automatic focus mode (autofocus), your camera will refocus on whatever is behind the animal. If the animal then comes back into shot it will be out of focus for a while and you'll see the camera 'hunt' for focus, thereby ruining the shot. There are many other situations where automatic focus can spoil a take – so use it sparingly or not at all.

Hopefully all the wildlife you film will be in the wild, but if you do have to film through the bars of a cage in a zoo, stand close to the bars and focus manually on the subject, to prevent the camcorder autofocusing on the bars.

Pulling or throwing focus can be an effective technique if you don't overuse it. This involves shifting the concentration of the viewer from one subject to another using focus – for example we may start a shot focused on a rabbit peacefully nibbling grass and then *throw* focus to the fox behind, preparing to pounce.

Pulling focus is the opposite – refocusing on a subject closer to the camcorder. Of course you need to use manual focus for this and practice the technique. Timing is crucial or the fox will pounce at the wrong moment and you'll miss the action!

Depth of Field – this is the amount of the image that is in focus in front of and behind the subject. If your subject animal is in focus, and all the habitat around it is also in focus, you may describe that as a wide depth of field – or deep focus. This is ideal in many situations. If only a small part of the image is in focus – let's say a close-up on the head of a gecko produces a shot with the eye in focus, but the tip of the snout and anything from the neck backwards out of focus – then you would describe this as a narrow depth of field, or shallow focus.

The factors determining the depth of field are:

- Distance from camcorder to subject – the greater the distance the greater the depth of field.

- The focal length of the lens (or amount you are zoomed in). At the telephoto end you'll have a narrower depth of field than with a wide angle setting. This is also why, when following movement, the wider the setting the less likely the subject is to go out of focus.

- Iris size – a narrow iris in bright conditions will produce a greater depth of field.

You can manipulate these three factors to create the depth of field you require. For example – portraits of animals, such as the head of a cheetah against a busy bush-background, may look more attractive if the background is out of focus – causing the cheetah's head to stand out more. You could achieve this by zooming in on the head and/or moving closer or by opening the iris wider (see below).

Exposure – this refers to the amount of light coming through the camera lens controlled by the size of the iris – an opening between the lens and the CCD which narrows to reduce the amount of light when conditions are very bright and vice versa. Many users leave their camcorders on automatic exposure which produces perfect exposure in most situations, but it pays to

experiment with the manual options in case you need them in the future.

Many camcorders have a backlight compensation button which, when pressed, opens the iris to allow more light through. You would use this when shooting a subject against a bright background – filming a bird in a tree against a bright sky is a classic example. With autoexposure the bird would appear very dark as the camera adjusts exposure for the bright sky, so use manual exposure or the backlight button to increase the light and brighten the bird. The sky may become very white but as the bird is the subject of interest you have to live with that.

Another situation where you would want to use manual exposure is when you are panning from a dark area to a bright area or vice versa. Let's say you were filming a bird perched in a tree, which then took off and flew into a bright sky. In automatic mode you would see the subject suddenly darken as the background became brighter which may well ruin the shot – so set the exposure as you want it in manual mode, while the bird is in the tree, to stop this happening.

As you can imagine, many of these techniques will improve with practice and experience. Filming wildlife involves quite a bit of quick-thinking and planning ahead – studying the behaviour of your subject will enable you to better predict what it may do.

Shutter Speed – although camcorders don't actually have shutters this refers to the amount of time an electrical charge is supplied to the CCD to enable it to record an image.

A high shutter speed freezes motion (as it would in a stills photograph) to produce a blur-free shot. Most of the time you will let the camcorder control this automatically, but you may want to experiment with slower shutter speeds to produce creative shots such as blurred motion during a chase sequence.

White balance – light entering your camcorder will have different hues depending on its source:

- Tungsten bulbs indoors produce a yellow light

- Natural light on a cloudy day produces white light

- Natural light on a bright, cloudless day produces a pale-blue light

Although your camcorder will automatically try to correct the white balance there may be times when you want to adjust this manually. For example, if you were filming a sunset, the camcorder may adjust the balance as if it were indoors – creating an image with boosted blues and not letting you film the rich oranges and reds you desire. So experiment with your camcorder's white balance settings in these situations.

You may see some camera operators holding a piece of white card in front of their camera before recording. This is basically showing the camera what is 'true white' in any lighting situation so that it can set the correct white balance. Your camcorder may have this facility – check the manual and try experimenting before you get in the field.

Composition – how to set up a good-looking shot in the frame. For some this comes naturally, for others it is a skill that can be learnt and practised. There are a few helpful rules that you can bear in mind when composing your pictures

- **The Rule of Thirds** – this technique involves imagining that your frame is divided into three, vertically and horizontally, giving you four points where the lines cross known as the *thirds*. Avoid the tendency to place your subject in the centre of the frame – it almost always looks aesthetically more pleasing when placed on one of the thirds.

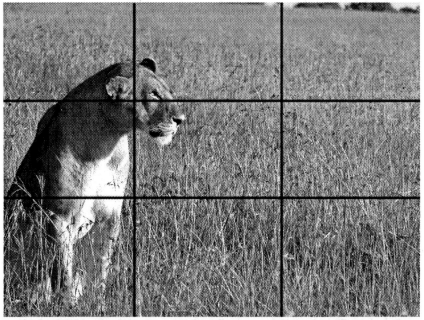

Note the head of the lioness has been positioned on the top left third – a more pleasing composition than in the centre

Similarly a landscape looks better if the horizon is on one of the thirds rather than half way down the frame. Which third you use depends on the situation and which part of the picture is of most interest. If you are filming a sunset for example it is likely that the sky and the clouds are of most interest, so the horizon should be on the lower third. This is another technique that is just as applicable when shooting stills.

- **Looking-Room** – if your subject is looking towards the side of the frame make sure you give it plenty of space to look into as in the example above.

- **Walking/Swimming-Room** – similarly if your subject is moving towards one side of the frame, and you are panning/tracking to follow this, make sure you leave it plenty of room to move into. If the tail end of the animal goes out of frame now and again this doesn't matter – but if the

head goes out of frame it can ruin the shot. It takes practice – especially with a running cheetah!

In this shot of a lion cub in the Masai Mara in Kenya at sunset, the horizon has been placed in the lower third, as the more interesting area is the clouds behind the cub rather than the ground below it

Shot size – don't fall into the trap of using just mid-shots where the whole animal is in frame; combine these with a few extreme long shots (also known as *wide* or *establishing* shots) to give scale and location, and some extreme close-ups – focusing on the eye, paw, twitching tail etc. You can never get enough close-ups!

So in any situation always aim to get at least three basic shots – a wide, a mid and a close-up – before trying others. Aim for maybe just ten seconds of each shot. Then even if the animal flees after just thirty seconds you still have three shots that can be edited together to make a mini-sequence. If it is an unusual sighting that might be the only chance you get. Once you have those three basic shots in the bag then you can think about

others, maybe changing angle or position, thinking more creatively.

Wide

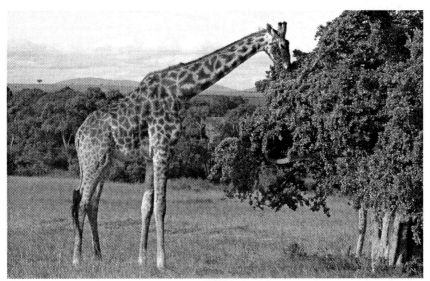

Mid

Close-up

Shooting sequences – remember that you will be building your shots into a series of sequences that tells a story. So get a variety of shots that will cut together well. If you come across an interesting situation (such as a predator on a kill) the tendency is to keep recording in case you miss something – but you can end up with hours of similar shots that are impossible to edit together.

When you watch a wildlife programme on television you will see that the vast majority of shots are under ten seconds long – many of them only fractions of a second (especially where there is fast action on screen such as a fight or chase). So compose your shot (let's say you start with a mid-shot), record about ten seconds, stop recording, recompose a close-up, record another ten seconds or so, stop, pull back to record the wide, and so on. You will find these shots much easier to edit together and it will force you to think about composition and sequences rather than just waving the camera about in record mode until the wildlife has gone to sleep And of course always be prepared to break rules – if you are following a tremendous chase keep following the action. You can always compose some wide shots later.

Shooting ratio – the amount of footage you record compared to the amount used in your finished film is known as the *shooting ratio*. For example if you went on safari and recorded ten one-hour tapes, and then edited this down at home to a thirty minute movie, your shooting ratio would be 20:1.

In the days when film stock was an expensive part of the budget the shooting ratio was very important and camera operators were encouraged to work towards a low shooting ratio. Now that you can buy a sixty minute tape for just two or three pounds you may think this is no longer an issue – but if you returned home with thirty tapes (a high shooting ratio of 60:1 if you are making a thirty minute movie) – you will find the reviewing and then editing of tapes a much larger task. If you (or a producer in a professional production) were paying an editor/studio per hour then this would significantly dent the budget. But even working on your own production you will find it harder in the edit stage if you have a high shooting ratio.

So if you are collecting footage for a specific film think about how important each shot is, and where it will fit in the story, before you hit the record button. Also think about the composition and length of shot in advance of recording. If something goes wrong then by all means repeat shots, and if something unusual or exciting is happening then of course keep rolling to catch all the action. But planning each shot usually results in better footage and a lower shooting ratio.

Zooming – almost always left out in the edit unless you are emphasising a distance. It can be effective to focus on the head of an animal for example and then zoom out to show how far away it is or to reveal its location. It works the other way around too – zooming in on a distant tree to reveal the small creature hiding in the leaves and so on. Of course use the zoom to compose your shot, but don't record endless zooms unless they are important creatively.

Camera Angles – get down to the level of the creatures you are recording, especially with small animals such as insects. Put the camcorder right down on the ground if necessary – mini LCD monitors that you can swivel up are useful in this situation. Looking up at something is nearly always more interesting than looking down, but often the best approach is to get the lens at the same level as the eye of the subject – known as the *eyeline.*

**Getting two Canon XL1s camcorders down to the
eyeline of meerkats in a wildlife park**

Point of View (POV) – these are camera shots from the point of view of the creature you are featuring. For example if you have just filmed a meerkat looking around the sky for predatory raptors it can be effective to follow this with a shot panning jerkily around the sky as if you were looking through the meerkat's eyes. Another effective shot is to hold the camera just above ground level and run with it to give the effect of a small animal running along. Use jerky movements (if this is how your subject behaves) and set the zoom to the widest setting (i.e. not zoomed in at all).

Panning – can be used to survey the environment you are studying, or to follow the movement of an animal. Note the classic technique of following an animal for a certain distance, or while it displays a certain behaviour, and then stopping the pan to let the animal walk out of frame – this produces an excellent cut-point or sequence end.

Panning can also be used to move from one subject to another. For example you could be filming a group of lions feeding on a kill, and then pan to one side to reveal the hyenas waiting for the lions to move off the carcass.

If you are panning to show a location always practise the pan several times before pressing the record button: get the speed right and the start and finish points where you want them. When you are ready; start recording, count a few seconds, then start the pan, pan smoothly to the finish point then count another few seconds before stopping recording – this gives you plenty of scope in the edit to use the pan in different ways.

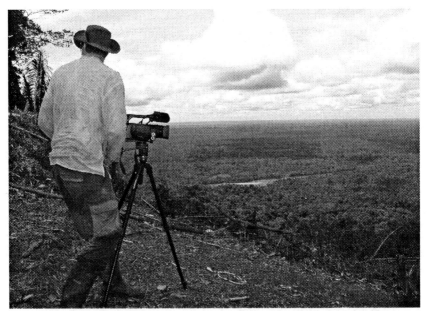

Preparing a landscape pan – in this case using a Sony Z1 on a tripod to pan across the rainforest in Ecuador from the summit of Armadillo Mountain

Tilting – similar rules to panning (sometimes called a vertical pan) but tilting the camera up or down. For example shots starting at the base of a tree and tilting up into the canopy can be very effective. Again – always practise first, keep the movement smooth, and use a tripod if at all possible.

Tracking – following a subject by moving the camera rather than just panning from one position. Practise moving on foot with the camera – in particular you want to avoid the camera bobbing up and down as you walk. Professionals may use tracks (like train tracks) and dollies (wheeled contraptions which hold the camera steady and run on the tracks) but these are expensive, heavy and difficult to use in the field on rough terrain.

There are ways to improvise though – having someone push you along in a wheelchair or go-kart while you are filming (if the ground is smooth enough) or shooting out of the vehicle window while someone else drives. For low tracking shots (following a snake slithering through the undergrowth for example) you can steady the camera by suspending it in an old shopping bag with a hole cut in the corner for the lens.

You may have heard of Steadicams which involve a complicated harness with weights worn by the camera operator enabling him or her to keep the camera relatively steady while walking or running after a subject. In practice these are rarely used in wildlife films – they are expensive and usually involve hiring a specialist Steadicam operator. With the nature of wildlife, of course, you can never be too sure when one would come in handy. But you can improvise a stabilising set-up with a monopod or closed tripod (or broom handle) with the camcorder at the top and a weight at the bottom. Hold this in front of you and you can keep the camera more stable as you move – but your arms will ache after a while!

Cranes – recently there has been an increase in the use of cranes in wildlife films, for those over-the-edge-of-the-cliff shots for example. As you can imagine, professional camera cranes are yet more expensive pieces of kit that can instead be improvised. A simple beam of wood with the camera fixed to one end can be suspended on a rope from a tree branch, tripod etc and swung around to give that feeling of smooth movement – as the camera moves up into the tree canopy for example. Or lower your camera in a bag attached to a rope over the side of a cliff for some unusual sequences.

Aerial Shots – these can add a great deal to your production if relevant, and assuming you can't afford a helicopter straight away, can be achieved using tiny cameras in model aircraft. You could try joining forces with a local model aircraft club – they may enjoy the challenge and help you get some aerial shots for no cost.

Another technique is to slide your camcorder (suspended in a bag or harness) along cables attached between trees.

Slow Motion – involves filming at a higher speed than usual so, when played back at normal speed, the action (such as a bird flying) will appear slowed down. Most productions use specialist high-speed film cameras for this, but a few camcorders have a higher speed facility.

Time Lapse – if your camcorder has this facility then you can get some fascinating shots of flowers opening, snails crawling, caterpillars eating a leaf, maggots devouring a carcass and so on.

It entails setting up the camera to take a number of frames at certain intervals – for example every 30 minutes. Then when played back at normal speed a few days will be condensed into a few seconds.

**The growth of fungal bodies can prove an
effective subject for time-lapse filming**

Cutaways – these are shots which interrupt continuously-filmed action by inserting a view of something else. Extremely useful in the editing process – always get a few cutaways when filming in the field. They can help avoid filmic nasties during editing such as jump cuts – when one moving subject in the frame appears to jump to a new position at the edit point. They can also be used between sequences to help change the subject. Examples are a close-up of a flower, a view of a stream, the sky, a tree, the landscape and so on.

**A photogenic shot such as drops of morning dew on
a cobweb can make an attractive and useful cutaway**

Interviews – the trend for using people in wildlife films comes and goes and you may or may not want to include interviews with people in your documentary. If you do use interviews there are two options for filming them:

1. **Without showing an Interviewer** – this is the easiest option but you need to brief your interviewee that they must include the question in their answer. For example if you ask them "How many years have you been working in the wildlife park?" they may simply answer "Five" which won't be easy to work into your film! Make sure you get the answer you need – i.e. "I've been working in the wildlife park for five years".

2. **Showing an Interviewer** – even if you are including a separate interviewer to ask the questions this can still be recorded with one camera. First record the interviewee answering the questions, then record some 'noddies' – these are over-the-shoulder shots from behind the interviewee looking at the interviewer pretending to nod in interest as the interviewee speaks. Finally record the interviewer asking the questions – the interviewee does not of course need to be there for this. These three types of shot will edit together well and the audience will be none the wiser.

In both cases of interview it also pays to record a number of cutaways to break up the monotony of looking at the same shot of the interviewee talking at length. Classic examples are close-up shots of the hands gesturing as he/she speaks, or a wide shot of where the interviewee is sitting/standing in the landscape/room. Again these would be recorded after the main interview.

An over-the-shoulder interview. In this case Ritish Suri is being interviewed about the wildlife at Corbett National Park in India

Interviews need not be formal, set-up affairs. Here John Parmasau is talking about the wildlife of the Masai Mara whilst leading a walking safari

One other point with interviews or when filming faces is that if they are shot against a bright sky you will find their faces are under-exposed – i.e. too dark. To get round this you either need to shoot them against a darker background – a tree for example – or light up their faces. The easiest way to do this is to use a reflector. You can buy special reflectors for this but they are easy to make with a large piece of white card or material – or cover a piece of card with cooking foil for an even brighter reflection. Place this out of shot to reflect sunlight into the face, adjusting the angle carefully to achieve the desired effect. The reflector can be held by the interviewee, by an assistant, or simply propped up on the ground.

Logging – not the favourite task of many camera operators but a very good practice to get into if you are planning to edit your footage into a film. Logging in the field is usually done by the camera operator or assistant in the evening after a day's filming.

It involves viewing all the footage recorded that day and making notes for each shot to help in the editing process and keep track of what useable images you have captured. On a sheet of paper start by writing at the top which tape it is (e.g. P. Warren – Basking Shark Encounter – Tape 6 – June 2006). The three most important pieces of information to log are:

1. The **Timecode** of the shot – e.g. 00:22:45:00 – 00:23:00:00. This is known as SMPTE timecode and gives you a position on the tape in hours:minutes:seconds:frames. Most camcorders will record timecode along with the picture and sound and give you an option to view the timecode when reviewing/logging your shots. In the above example we know the exact position on the tape we are referring to and that the shot we are describing is 15 seconds long.

2. The **Subject** of the shot – e.g. *basking shark surfaces then turns away from camera with mouth agape.*

3. The **Quality** of the shot – an important note to yourself or the editor for later such as *out of focus do not use*, or *good cutaway*, or *excellent close-up – use this ...*

P. Warren – Basking Shark Encounter – Tape 6 – June 2006		
Timecode	**Subject**	**Quality**
00:22:45:00 – 00:23:00:00	basking shark surfaces then turns away from camera with mouth agape	excellent - use for end of sequence

**Gareth Trezise logging shots back in camp
after a long day in the field**

Note that if you have rewound the tape in your camcorder to check what you have just recorded, and then start recording again, leaving a tiny gap after the last shot, you will lose the previous timecode on the tape and the camcorder will start recording timecode from the start again. When the tape is full you may have several timecode start points which will confuse the editing program and make your logging more complicated. So either resist the temptation to keep viewing what you have just shot, or make sure you start recording over the last second

of the previously recorded shot so that the camcorder can pick up the timecode.

Labelling Tapes – it may sound obvious but I can't stress enough how important it is to label your tapes, DVDs etc. At the least annotate each one with your name, the date of filming and subject area – it will save time and frustration when editing, stop you overwriting important originals, and stop wear on the tape and camera if you continually have to search tapes to see what's on them!

Recording the Sound – most people forget how important sound is in a film and start by just recording whatever sound there is through the camera's microphones as the picture is recording. But, as already discussed, you will get better a sound recording if you use extra microphones that you have positioned carefully. Ideally the microphones will be as close to the sound source as possible without causing any disturbance.

Most camcorders will default to setting the sound recording level automatically – known as *auto gain control* (AGC). The problem is that if you have a sound level that changes – such as when a red deer roars loudly over a quite atmosphere – you will hear the level of the atmosphere change, which can ruin the recording. So it is better to use manual gain control. Set your audio record levels to peak just before distortion (a red mark/light you will find on your record-level meter) when the loudest sound is occurring. Also use headphones to monitor the sound as you record it so that you can check the quality.

Whatever situation you are in make sure you record plenty of atmosphere (in stereo) for use later in the editing stage. You can record this direct into the camera if you don't have a separate audio recorder – keep the lens cap on and just record several minutes of atmosphere in each location – ideally without the noise of planes, cars, people etc. Atmospheres are also known as wild tracks or buzz tracks.

Recording the atmosphere of a lake-side habitat using two mono microphones to create a stereo recording

Equipment Care – Camcorders are well built on the whole but do contain some delicate electronics and need to be handled carefully. Here are some tips for caring for your equipment:

- Don't let your camcorder get wet. If working in humid conditions such as rainforests keep your equipment when not in use in ziplock plastic bags or waterproof cases with sachets of silica gel (these can be purchased inexpensively from eBay). Always take a number of old supermarket bags for emergency rain-covers.

- If you move your camcorder from somewhere cold to a warm room or humid environment, condensation will build up on the lens and video-heads. Leave it a while to acclimatize before recording or storing.

- Do not leave your camcorder in direct sunlight when not in use – or point the lens or viewfinder directly at the sun.

- Keep the lens-cap on when not recording.

- Clean the lens regularly with a lens-cleaning cloth or lens-fluid and cotton buds.

- Use a photography-blower and brush to remove particles of sand and dust from all parts of the camcorder.

- Fully discharge batteries before fully charging to maintain maximum capacity.

- Remove the batteries while the camcorder is not in use for long periods.

- Stores tapes in a cool, dry environment away from strong magnetic sources.

Fieldcraft

Fieldcraft is the name we use to describe the art of understanding your natural environment and using techniques so that you can get close to your subjects.

If you have a subject in mind – such as a family of badgers in a nearby wood – then a good first step is to find out all you can about the animal from books and the Internet. What are its habits, what time of day or year does it do certain things, what behaviour can you look out for? What are its senses – keen sight, keen smell? All these points will help your fieldcraft, and by increasing your knowledge of the subject you will inevitably end up with more interesting footage.

As far as proximity to your subject is concerned, the aim is to get as close as possible without the animal(s) knowing you are there. This means not being seen, heard or smelt. To avoid being seen you have either to hide behind something, or to blend in with the environment. If you are lucky enough to have the subject of your film in your garden then you may be able to hide indoors and film through a window.

The key here is to draw the curtains well in advance of the animal's appearing. If you are afraid of the curtains moving and spooking the subject you can even tape them to the window frame, then stick the lens of your camcorder through a gap in the curtain (no – don't cut a hole), again using tape to form a suitable hole for the lens. Don't actually tape the curtain to the lens or a slight movement of the camera will make the whole curtain ripple.

You need to have the camcorder lens very close to the glass (which you will of course have scrupulously cleaned well in advance) to avoid reflections. Make sure the camcorder is at a comfortable height – you may have to spend long periods sitting or lying with your finger hovering on the record button waiting for something to appear. This method allows you to come and

go, make a cuppa, go to the loo etc without disturbing your subject.

Hide and Seek

If you are outside then you have several options: you could use a makeshift hide (shed, hedge etc), make one out of your natural surroundings (tree branches, rocks, plants etc), or use a portable hide. The advantages of modern hides are that they are well camouflaged, waterproof, easy and quick to erect, have numerous openings for your lens, and pack up small and light for carrying home in your rucksack. The hide can be further camouflaged using local materials – branches, leaves etc, but don't cause damage by ripping branches off trees for this purpose – just use what you find lying around on the ground.

A modern dome hide

Bear in mind that you may have to let the wildlife become accustomed to the presence of the hide – gradually moving it closer to the edge of a lake for example, and leaving it some days before attempting to film. Of course this has to be in an area where you are happy the hide won't be stolen!

Don't forget you will be seen entering your hide by the wildlife, so you may need to creep in before dawn. One trick, based on the

assumption that most animals cannot count, is to have two people enter the hide, and then one leave after a few minutes. Prepare yourself for long waits in the hide with food, drink and a receptacle for when you need to relieve yourself – if you leave the hide you may well have blown your chances for the day.

Be a Chameleon

Blending in with the environment without the use of the hide means using the correct clothing and equipment. Use as much camouflaged clothing as you can – trousers, jackets, gloves, headgear etc. These can be bought either from specialists (see *Further Resources* at the end of the book) or from your local army surplus store.

Don't forget to cover all your skin including hands and face with gloves and balaclavas or with face-paint (army style) or even mud. You can further disguise your outline with netting (scrim) – in fact a simple technique is to take a piece of netting about 3 metres x 3 meters square, lie down in position and cover yourself and your equipment entirely.

Fully camouflaged – body and equipment

Your equipment also needs camouflaging, and there are various ways to do this. One method is to cover (parts of) the gear with

camouflage tape, but this tends to be rather permanent and in any case you need to leave all the controls uncovered. You can get a variety of ready-made covers such as tripod leg-wraps, and an easy technique is to get a large piece of camouflage material and make a kind of bag out of it with a hole at one end for the camcorder lens. Then you lie down with your head, hands and camcorder inside the bag with just the lens peeping out. Netting is a good choice for part of the material or you will find the bag stuffy and your breath will fog the viewfinder. Ensure anything shiny and silver is well hidden.

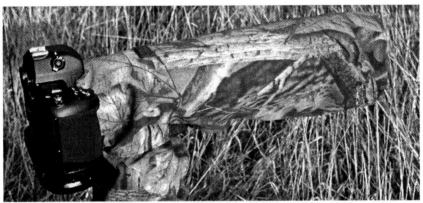

**You can buy ready-made camouflaged lens covers like this
or make your own out of camo material**

Quietly Now

Not being heard is largely down to a careful choice of clothing and equipment. Avoid materials like nylon that swish about as you move – army camo gear is wonderfully quiet. Also avoid Velcro and zips on anything that may need to be opened in the field. That loud tearing sound as you rip open the Velcro flap on your gadget pocket will rapidly disperse the wildlife – away from you! Replace these with flaps or buttons: you can even temporarily tape over Velcro.

Check the rest of your equipment for rattles and noisy bits. Common problems occur with the clips where you can fasten straps – these can easily be silenced by taping them up – soft

plastic insulating tape will do – black, brown or dark green of course.

Moving quietly is a necessary skill for the wildlife film-maker and a question of practice and common sense. Move every part of your body slowly: it is tempting to whip your head round if you hear something, but then the creature will be gone. Turn your head slowly and use the corners of your eyes.

Walking in forests is hard to do silently but you can reduce the twig-snapping and crunching by placing your feet down slowly heel first, then lower the toe. If your start to disturb a noisy twig you can pull back and adjust your step. If you know the wildlife you are trying to film will appear at any moment, make sure the camcorder is in position for filming, then all you need do is silently press the record button.

The other challenge is not to be smelt by your quarry – humans stink strongly as far as most animals are concerned. The first rule is to use no aftershave, perfume, artificial scents of any kind, and certainly don't suck mints or chew gum in the field!

Otherwise the key thing is to rely on the wind to keep your smell away – always keep downwind of your subject. Wetting your finger and holding it up is not a reliable method of determining the wind's direction. A more accurate option is to trickle a pinch of something lightweight (grass, sand, dusty soil, bits of dry leaves etc) from your fingers. The best method of all is simply to use the feel of the wind on your face – rotate your face slowly until you feel the breeze is dead centre. If your subject is then in front of you, you are in a perfect position downwind.

The other part of fieldcraft is finding the animals in the wild that you wish to film. The key is to be in the right place at the right time – and this comes with a combination of research, personal experience, and asking local experts for advice. Even better is to take with you a personal guide who is knowledgeable about how to find the wildlife at a particular location. Try your local wildlife trust for ideas.

Once you are in the right place it's a case of learning to use your eyes and ears effectively. Scan with your eyes, and cup your hands behind your ears – searching for any noise or movement that might give away the position of the creature you are after.

Set-Building

The alternative to filming wildlife in the wild is to create a temporary set for filming small creatures.

Far more wildlife programmes extensively use sets than the public realises. This is especially true of small creatures such as rodents or insects, and many close-up underwater scenes are actually shot in aquaria. There are huge advantages to having the creatures on hand – you can film at your leisure without having to search the wild for them, and it is also easier to wait for the appropriate behaviour. Set-building can also be great fun.

The first decision is whether to have your set indoors or out – out will give you natural lighting but bad weather could destroy it. If you have adequate lighting that imitates daylight then an indoor set is a better option.

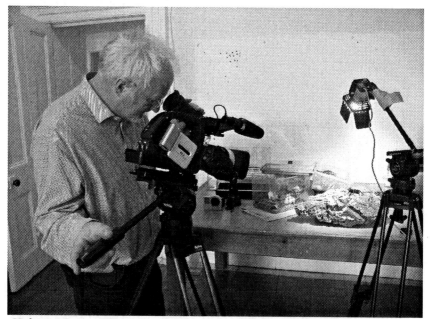

**Using a Canon XL2 to record a tarantula on a large piece of bark –
sets don't have to be complicated affairs**

If your subject is very mobile, such as a mouse, then you are better off using a glass tank – ensuring the glass is very clean. You will have to play around with the positions of the lights to avoid reflections (attaching a large piece of black cardboard with a hole cut in it around your lens will help). Set the camcorder up on a tripod close to the glass – the black card will also hide the movements of your hands from the animals.

If your subject is less mobile, such as a snail or caterpillar, then you could use a large cardboard box with the front cut away. The extra advantage of this is that you can then move in much closer to the creature – modern DV camcorders on the widest zoom setting can let you get incredibly close – filling the whole screen with a spider for example. With the right lighting this can produce stunning images very easily. Some popular films such as *Microcosmos* (which was a cinema movie focusing on the small creatures living in a French meadow) were largely shot in sets.

A simple studio set improvised in a jungle lodge in India, made out of a cardboard box and a piece of black material (velvet is good). Here the subject is a small kukri snake on a branch

As far as the decor goes, it is simply a case of mimicking the natural habitat as closely as possible. Use a mixture of soil, bits of rotting wood, leaves, moss, stones, living plants etc as appropriate, and arrange them untidily. Remember to build up the back and sides of the set as they will be the backdrop for your film.

The same applies if you are setting up an aquarium to film small fish, tadpoles, aquatic insects and so on. Using a small pump (known as a *powerhead,* obtainable from an aquatic/pet shop) can give the impression of a current in the water which adds to the illusion. Once you start building sets you will find it an addictive hobby – whether you use your camcorder in the end or not!

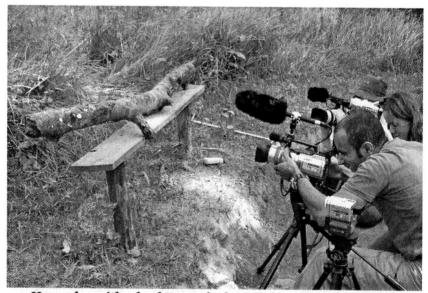

Here a log with a background of grass provides a simple but effective outdoor set for filming a venomous Russell's Viper in India

Sets can also be created to get specific shots. For example I once worked with the Indian wildlife film-maker Captain Suresh Sharma whose speciality was to create realistic burrows and tunnels to film snakes slithering along in their search for prey such as rats. He would start by covering a drainpipe with bits of

roots and a layer of mud, let this dry in the sun then pull out the pipe, teasing the roots so that they hang down in the tunnel and making some holes in the top to let light through. He would then set up the camera at one end and introduce a snake through a hole in the top of the mud tunnel – getting great footage of it progressing through a burrow.

Note that he was also an experienced snake-handler – I don't advise you to do this at home with snakes, but it would have the same effect with other small creatures. It gives you an idea of the length some film-makers go to in order to get shots for sequences – several days' work may represent only a few seconds of footage on the final film.

Wildlife film-maker Captain Suresh Sharma feeds a red sand boa into an artificial tunnel he has created out of mud. This is being filmed through the open end of the tunnel to the right

Welfare

Before populating your set you need to think carefully about the welfare of the animals. Indeed taking many creatures from the wild (newts for example) is forbidden and illegal – and rightly

so. If you want to film caterpillars eating a pot plant for example, then you can move the plant into the set, take your footage, and then return the plant to where you found it with no damage done. Temporarily moving a few snails, woodlice, pond creatures etc from your garden into your set will not cause any problems – the rules being to keep them in captivity for as short a time as possible, and always return them to exactly the spot where they were found. Take especial care to ensure the artificial lighting does not cause heat-stress.

But you may find this short visit to the set does not produce the behaviour you are after – breeding for example. In this case you will need to have an established long-term set that the creatures have become accustomed to. A good example here would be to bring in some frogspawn from your pond, establish it in an aquarium, and film the stages of development of the tadpoles. The froglets will need to be returned to your pond once they start to leave the water, however. In order for conditions to be as natural as possible you should ensure the set is large and contains everything the creatures need in the way of food, shelter, temperature etc.

Use your common sense to decide which creatures can be removed from the wild to introduce to your set. A few common bugs will be okay, but avoid wild mammals, birds and anything rare or unusual. There are many unexpected pitfalls – you may unwittingly be removing a mother from her young for example. That doesn't mean you can't film these creatures in a set – many wildlife films use creatures born in captivity for that purpose. A trip to your local pet or aquatic store will produce many photogenic creatures – fish, spiders, snakes, insects, mice and so on.

You should be aware that it is illegal to handle certain animals without an appropriate license – bats for example – if in doubt ask your local Wildlife Trust for advice.

Remember you may need a license
to handle creatures such as this
brown long-eared bat

Ethics

Having mentioned welfare we also need to discuss the wider issue of ethics when using your camcorder to record wildlife. Companies such as the BBC have their own ethical rules for wildlife documentary-makers, and the organisation Filmmakers for Conservation has produced a set of principles and guidelines for working in the field as follows:

Principles

1. Always place the welfare of the subject above all else.

2. Ensure that your subjects are not caused any physical harm, anxiety, consequential predation or lessened reproductive success by your activities.

3. Don't do anything that will permanently alter the natural behaviour of your subject. Be aware that habituation, baiting, and feeding may place your subjects at risk and may be lethal.

4. It is unacceptable to restrict or restrain an animal by any means to attract a predator.

5. Subjects should never be drugged or restrained in order to alter their behaviour for the sole purpose of filming.

6. Be aware of and follow all local and national laws regarding wildlife where you are filming.

7. Be courteous to your contributors (give appropriate credit where it is due). Whenever possible give copies of the finished programme, a copy of a long edit of an appropriate scene, and/or publicity photographs to the people who helped you.

8. Images or scripts that give an audience abnormal, false or misleading information about a subject or its behaviour should be avoided.

9. Always research your subject prior to filming.

Guidelines For Working in the Field

Restore all sites to their original state before you leave (for example: prepare scenes by tying back rather than cut vegetation).

Be aware and take precautions, as some species will permanently quit a site just because of your odour.

Keep film, video equipment, and crew-members at a distance sufficient to avoid site or subject disturbance.

Night shooting with artificial lights can require precautions to avoid making the subject vulnerable to predation.

Be prepared to meet unexpected conditions without damaging the environment or subject. Be especially prepared and deal with any people attracted by your activities as they could put the subject at risk.

Be aware that filming a den or nest site could attract predators.

The use of tame or captive animals should be acknowledged in the film credits.

If using tame or captive animals:

 a. Ensure the subject receives proper care.
 b. The subject's trainer or custodian should always be present during filming.

The End Product

It's all very well filming hours and hours of wildlife behaviour – but what will your final product be?

Let's say you have got to the point where you have numerous tapes full of raw footage of wildlife – now how do you turn this into an enjoyable movie, and then what do you do with it?

You may think the next step is editing – but wait! Too many people start dumping footage into their PC (or whatever editing environment they are using) without a clear idea of what they are going to do with it. So the first step is simply to look through all the raw footage you've got – direct, by plugging your camcorder (or tape player) into your TV – and come up with a plan.

You may well already have a clear idea of what you want to do with the footage – and in some cases reviewing the raw footage will help develop an idea in your mind. It may also change your mind – a common example is when you plan to make, say, a half-hour movie about squirrels in your garden, but find the amount of interesting squirrel footage amounts to only a few minutes. So you have either to change your mind about the end product, shoot loads more footage, or to change the emphasis of the film – maybe a theme of 'your garden through the seasons' will be more appropriate.

So before we look at editing and post-production we should explore some possible end-products to aim at:

1. **A movie on VHS or DVD** for you and your friends to watch on television. This is the simplest case in that there are few limits on length or content. That doesn't mean you want to produce a boring film! A common mistake with amateurs is to include far too much that is of little consequence, resulting in a slow, dull experience. Aim for

the finished result to be half an hour rather than an hour – be ruthless – only choose the sequences that are great viewing and essential for the story of the movie. To make up that half hour you may need to extract sequences from many hours of raw footage. Be prepared to forget sequences that may have taken you hours to achieve if they are of inferior quality or do not fit in with the story. You never know – you may be able to use them on another project anyway.

2. **A movie for web-streaming or emailing**. In this case you are probably aiming for something only a few minutes long – so be even more ruthless with your choice of sequences. The final result will need to be compressed using software such as Adobe Premier and saved as a file such as an mpeg. Experiment with video lengths and sizes of frame until you get a file size that doesn't take hours to download. Until everybody has broadband people will not want to wait more than ten minutes or so to download a movie – unless it is something they desperately want – so aim for no more than a few Megabytes.

3. **Clips for a multimedia CDROM/DVD**. A more flexible approach is to use short clips linked together with an attractive interface. For example if your subject is badgers, then you can have a number of edited sequences covering feeding, breeding, rearing offspring etc, which the user chooses from a menu via their computer or DVD player. Use stills, or video grabs (individual frames saved as a still images) from the movie to create the interface – there is a lot of software available these days to help you produce this. The disc can then be sent to friends or, if good enough, sold (see 4 below).

4. **A movie on VHS/DVD to sell**. A good example here would be to produce a birder's guide to a particular birding hotspot. For this you could team up with a bird expert who can help identify the species and maybe provide the narration or even act as on-screen presenter.

 If you have enough material here you could aim for an hour-long piece. This will involve some investment up front as you will have to pay for VHS/DVD copies, labels, cases, printed covers etc. Sales could be through; your website, local press review, local television, magazines (e.g. *Bird Watching*), Wildlife Trust Centre, nearby outdoor/wildlife shops and so on. You will have to work hard to produce a good result as your reputation will depend on it – get it right and it could be the start of a series.

A DVD to help people identify gulls – such as these ring-billed gulls – could form a saleable product

5. **A clip for local television**. If you have recorded something unusual of local interest, such as sighting of a rare bird or animal, cute fox cubs in an unusually-

situated den, or a wildlife pond threatened by a new development, then you may find your local television broadcaster is interested in including it in a local news programme. And they should pay you for this too. First ring up and describe the footage and assess their interest – then take it in on VHS for them to view, pointing out that you have a higher quality version (e.g. on miniDV) should they wish to broadcast it. Remember they will use only a matter of seconds – so just include the most striking shots. Don't add music or narration as they will use their own voice-over.

Footage of environmental damage may be used by local television broadcasters. It may also help expose and reduce the damage – in this case the removal of important mangrove habitats in the Bahamas to build luxury homes

6. **Other television opportunities**. There are occasional wildlife television programmes that will take footage from amateurs – obviously it needs to be as high quality as possible – ideally at least 3-chip DV.

7. **As a showreel looking for work.** If you are hooked, and want to be a professional wildlife camera operator, then your footage can be used to create a showreel to send to prospective employers. This should be about five minutes (never more than ten) of varied footage showing what you are capable of.

It could accompany a pitch (proposal for a new programme) if you have a strong film idea as well. It has to be stunning – or why should they use you rather than the camera operators they are accustomed to using? Package it in a video/DVD box with a well-designed inlay card. Also include your address, phone, email, website, details of equipment available, and locations for material on the showreel.

Here's a brief guide to what you might want include on your showreel:

If the aim is to get work as a camera operator then show that you know how to take different kinds of shot – include:

- locked-off shots
- survey pan left, survey pan right
- follow pan left, follow pan right
- whip pan left, whip pan right
- tilt up, tilt down
- zoom in, zoom out
- track forward (steady), track back (steady)
- lift up, lift down

Then about three minutes (12–20 shots) of material all on one subject, perhaps all one 'action', to demonstrate your ability to shoot material that will make a sequence – to give, when edited, an illusion of continuity. Assemble the shots in sequence story-line order and include an obvious cutaway or two.

Finally include an edited sequence to show your special interest (e.g. undersea, insects, or cutting pictures to music); or an edited 'promo' – two minutes for a programme idea of your own you'd like to be involved in. Subject matter should be very different from that in the earlier items.

Post-Production

As we have discussed there is no shortage of end-products for your wildlife footage. So, having reviewed the raw footage and decided on your aim, how do you turn the pile of camcorder tapes into the movie you want? The basics of post-production are similar whatever the end-product, so for this example we will assume that you want to produce a complete half-hour movie.

Planning

The first step is to plan your story – you may have (probably *should* have) done this before you even started shooting any footage. Draw a flow-diagram (storyboard) of the movie on paper – imagine how the narration will go – decide on the beginning and ending and then think about the sequences that will connect the two. They won't necessarily appear in the order you recorded them.

You also need to decide whether to edit the pictures first and then write a narration to suit – or write the narration to cover the story and then match the pictures to this. To start with you may find it easier to edit the pictures first, but bear in mind that the professionals sometimes do it the other way around. If you've watched any of the David Attenborough mega-series, you'll notice that often he starts a sentence in one location and then finishes it half way across the world: all carefully planned and written long before any camera crew were appointed.

If writing or narrating is not your thing then you may simply wish to edit your sequences and add music. There's nothing wrong with this – I've seen some fantastic nature films with no narration at all (e.g. *Microcosmos*) – in fact it makes your brain work more. I'm also all in favour of using nature images as an art-form – combining them with sound/music to produce a moving experience.

Editing

There are a number of choices when it comes to hardware and software for editing. The vast majority of people now edit on personal computers – the favourite combination currently being Final Cut Pro on an Apple Mac computer. The options for a PC include Avid Xpress DV, Adobe Premiere Pro, and many others. The programs and platforms are becoming more and more similar all the time, so do not get too bogged down trying to decide which system to use – at the end of the day they essentially do the same thing – so start with what you've got.

Editing a film about lions on Final Cut Pro

In fact when you buy a new computer it will come with basic video editing software loaded free – iMovie on the Mac and Movie Maker on the PC. These are excellent programs to get you started with editing and have the majority of functions needed to create a good wildlife film.

There are many approaches to editing video and this is one area where you could benefit from taking a short course to get you started. Basically the first job is to 'capture' your footage on to a hard drive – and it is recommended that you do this on a separate hard drive from your computer's main internal hard drive which contains all the programs etc. External hard drives are reducing in price all the time and will perform additional useful functions such as backing up important data from your main computer. Roughly speaking five minutes of digital video will take up about 1Gb (Gigabyte) of disc space – so an external drive of 80Gb will enable you to store over six hours of footage – but aim for the biggest drive capacity you can afford.

If using DV, the capturing involves attaching your camcorder to the computer via a connection called Firewire (you will also see this referred to as IEEE-1394) and your computer will need a Firewire video capture-card installed to enable this. Then from within your computer program you will go into *capture mode* and it will transfer the digital footage and sound on to the hard drive in real time. You will of course need to do this for all the tapes or parts of tapes you need to edit from.

Once your footage is on the hard drive it is a case of choosing the sections you want and placing them on an area of the screen called the *timeline* where you build the movie from start to finish, and add sound tracks underneath. There are various approaches for this. The subtraction method involves going through the captured footage, ruthlessly deleting all unwanted shots. You will find many sequences which will be minutes long but contain only a few seconds of useable material – so roughly cut these too. When you've done this with all the footage, go through again (depending on the length you have remaining and the length required for the movie) and again cut out anything that is not essential for the story, or not an outstanding visual, until you have roughly the right total length.

You might find this the easiest method to start with but ideally you will be choosing the perfect shots to build sequences that tell your story – rather than just deleting the worst bits!

**Editing is no longer confined to the studio! Rob O'Meara uses
an Apple PowerBook to start a rough edit during a
lunch-break whilst filming big cats in the Masai Mara**

Then it's a case of putting the sequences in the right order and doing the fine edits of each shot (getting the start and end points of each shot exactly right).

Your opening sequence may have titles, and could include a few dramatic shots from the movie under the intro music. Then the story starts: remember to set the scene with various establishing shots – possibly the landscape – and to start the story with some kind of question or dilemma to keep the viewers hooked (e.g. will the cubs survive the hard winter?).

Discussing development of the storyline during editing

Analysing wildlife films on television will give you lots of good tips for editing. For example

- Let a subject walk out of frame and then cut

- Never cut from the animal walking in one direction to walking in another

- Use cutaways such as a close-up of the animal's eye or ear or paw to avoid jump-cuts.

- Think in terms of thirty one-minute movies rather than one thirty-minute movie to help you handle the editing – baby steps (easier to think of it as small episodes).

- Start each new scene with an establishing shot (e.g. of the trees blowing in the wind) to show the viewer that time has passed.

- Close each scene by settling on an image for slightly longer than you would expect.

- If you are filming action, such as a fox chasing a mouse, then be aware of which directions the animals are going in – don't keep swapping round. If you are lucky enough to have action like this it is quite possible that you recorded the whole thing in one take for fear of missing something. But in the edit you can split it up with quick cutaways (shot at a different time – teeth in close-up for example) to make it more exciting and enable you to cut out the unnecessary bits invisibly.

Putting it all into practice – using Final Cut Pro on a G5 Apple Mac computer

Transitions

As far as transitions go (the joins between shots) you'll notice that nearly every one in professional wildlife movies is just a straight cut. You can possibly get away with a fade (dissolve) between scenes but all the wipes and swirly effects just look

hopelessly amateurish on a wildlife film so are best avoided. The exception to this is maybe the opening sequence under the titles, or the end sequence under the credits, where you can be a bit more creative. A simple fade to black and then back again is a useful transition for denoting a progression in time or change of subject.

<u>Sound</u>

As you are doing the picture editing you will need to pay careful attention to what is happening with your sound track. When you put in a cutaway you are unlikely to want to use the sound that went with that – but keep the continuity of the sound from the main action going.

Editing sound tracks on Final Cut Pro

As you go from one sequence to the next you may find a jump in the sound, in which case you will have to fade the audio out and in again at the junction. A lot of the time the sound may well just

be the atmosphere of the garden/wood etc, and if you have a badly recorded bit, or unwanted sounds such as traffic, then you may be able to replace this with some atmosphere recorded on another sequence.

Foley

If you really want to have fun with sound then have a go at recording your own 'Foley' sound (named after Jack Foley who established the basic modern technique while working at Universal Studios).

Next time you watch a wildlife film on television pay attention to the close-up sound – the little splashes as you watch a bird wading through water, the crunching as a fox chews a rabbit leg: hardly any of these sounds are actually the real thing. Usually that action is too far away or so quiet it cannot be adequately recorded.

The splashy sounds are made by dabbling your hand in a bowl of water, the crunches by chewing a stick of celery into the microphone. Other classic examples are footsteps made in a box of gravel or dried leaves, footsteps in the snow made by squeezing a rubber glove full of talcum powder, and the sound of a bird's wings made by flapping a piece of material in front of the microphone.

The trick is not to overdo it or make it too loud in the mix – the viewer must never suspect. Your software will have to enable you to mix extra sound tracks in to achieve this, but most packages have this facility.

You can record them either though a microphone directly into your computer, or even on to your camcorder sound track and then transfer them across. To get it really spot on you need to be watching the visuals while making the new sounds in sync. It's fun – try it!

Music

Music is nearly always used in the intro to a programme and at the end as the credits roll. Whether you use music in the rest of the film is up to personal taste. There are many people who feel that wildlife films should have no music at all in the content – just the natural sounds of the animals and atmospheres. But the majority of productions do have some music – in some cases composed specifically for the project such as the orchestral score composed by George Fenton for BBC's series *Blue Planet*.

The music can be incidental background to fill the silences (if you feel you need to) or carefully chosen to match the mood and build the drama. The style of the music could be any to suit your taste and the theme of the programme – classical, contemporary electronic, jazz, blues, rock etc.

Ideally, if you are a musician, you can write and record music especially for your own production; if not maybe you have a fiend or family member or local musician who would do this for nothing in return for the experience and showcasing their work.

**Charles Denler - one of the few professional musicians
who specialises in composing music for wildlife films**

If you use someone else's music from CD of course you have to be aware of copyright issues. Your favourite Led Zeppelin CD may provide the ideal music track to your film but if it was ever broadcast or shown to the public you would probably have to redo it with affordable music.

The other option is to use library music – there are many providers with many different deals – for example you pay per minute used, or buy a CD of music outright which you can use on any project. The problem with library music is you may find it hard to fit in with the drama of your film, and you may find other wildlife film producers have used the same music.

In general try to be subtle with the music – never overpower the natural sounds. Don't feel you have to have music all the way through. Try to match the feel of the music to the emotion you are trying to build – tension as the cheetah slowly stalks the gazelle, fast dramatic music as the chase starts, sad music as the hunt fails and the cubs go hungry. Use two of your tracks in the editing software so the music is stereo.

Narration

Writing and recording the narration are skills that are not easy to come by, so by all means collaborate with someone for this part. It may be tempting to do every part of the production yourself – but if your voice just isn't quite right then use someone else.

When writing your narration script – which as already mentioned you may have done before you even started filming, or may have left until just before or after the picture edit – remember it has to be a story with a beginning, middle and end. Aim for complete sentences but in language that you would use when talking, rather than if you were trying to write a literary novel.

Don't just describe what the viewer can see for themselves on screen, but give extra information to add to their understanding and experience. For example if the film shows a bird feeding its young in the nest, you don't need to say that the bird is feeding its young in the nest – but saying what species it is and how old the chicks are and how long they will stay in the nest is all interesting extra information that the viewer won't necessarily know.

Herpetologist Neil Das is being recorded talking about snakes on location. This recording will form part of the narration when the sound tracks are pieced together in the studio

Try to throw in some questions that will be answered later in the film – regularly giving the audience a reason to keep watching – "the abandoned cubs are old enough to feed themselves but will they survive the drought?" Occasionally you could use a 'tease' or a 'hook' to add tension such as "the lake looked peaceful enough but little did I realise what lurked beneath the surface".

When recording the narration imagine you are telling a story to someone sitting next to you. Pace yourself. Act out the part –

pretend to be a narrator – then develop your own style. Don't try and imitate another narrator like David Attenborough. Don't be afraid of sounding genuinely enthusiastic or amused. Read your script to several people before recording and get feedback.

Type your script out clearly and practise reading it several times. Mark emphases and pronunciations on the paper as a reminder. Don't talk too fast and don't feel you have to talk all the way through the film. Less is more. You can either deliver your narration while watching the footage, or record it separately (known as recording 'wild') and edit and place it on the timeline later. If someone else is reading the narration for you then sit with them and act as director – don't be afraid to ask them to re-read sections with different emphasis or speed for example.

When you are recording the narration choose a quiet room and draw the curtains (which stops sound bouncing off the glass causing reverberation). Set up a microphone on a microphone stand (or taped to a tripod) so that when you are sitting comfortably the end of the microphone is about 10cm from your mouth. Keep your head steady but relaxed as you record. Set up your script on a music stand so that you can read it clearly without moving your head or turning pages.

Wear headphones while recording and learn to enjoy the sound of your voice.

Another device you may use is a 'pop filter'. Whenever you say words with a 'p' or a 'b' sound you'll notice it causes a little blast of air from your mouth which can cause the microphone to distort briefly – known as 'popping'. A pop filter is basically a piece of material that reduces the air blast while allowing the sound waves through. You can buy professional pop filters or make one out of a piece of material cut from a pair of tights stretched over a coat hanger bent into a circle. This filter can then be set up directly in front of the microphone.

Home-made pop filter

Titles/Credits

Adding the titles and end-credits is the last stage of your edit. Traditionally the titles (preceding the show) just give the name of the film and then the name of the narrator if you have one. Then the end credits name everyone else involved in the production and thank any people or organisations as required. Even if you have performed many or all of the roles in producing the film, avoid mentioning your name numerous times in the credits. It is more modest and professional simply to say 'Filmed and Produced by Joe Bloggs' for example.

When designing the style of the credits it's best to avoid bright colours for the text which looks amateurish (white on black is often best) and don't make the font size too big. Scrolling upwards is the favourite – check the speed is not too fast to read or so slow it drags.

Once the edit is finished record a master copy of the film back on to a DV tape (direct into your camcorder or DV tape recorder) and/or on to DVD from which copies can be made.

Hey – you're a wildlife film-maker!

Evaluation

But before you rush off and make your next film, or send your first effort to the BBC or Discovery, get plenty of feedback. Ask a mixture of people to watch your film – different ages and interests (not just wildlife film enthusiasts!) – and write down their thoughts. What did they think of the picture quality, the narration, the music, the editing, the sound track, the overall length, the pace, the storyline and so on? Evaluate their reactions – was there a consensus that a particular idea that it was too long and dragged in places for example?

And then don't be afraid to redo part of the post-production as a result. You will have spent so much time on the production so far it would be a shame to draw a line under it now when a little more work could transform it. It may make a far more watchable film if you re-edit it to thirty minutes rather than an hour for example. Or it may benefit from a different narrator, or less music, or a different end to the story.

Whether you made a wildlife film as a pastime essentially for your own enjoyment, or with the aim of developing a career in the field, your finished product will be a creation to be proud of. You may even want to enter it in a film festival (note that many festivals have newcomer categories – if you research wildlife film festivals on the Internet you will find their competition entry details).

Good luck and happy wildlife film-making!

Further Resources

Wildlife Film News is a free monthly e-zine read by thousands of people involved with or interested in wildlife film-making, from all over the world. Issues typically include news about wildlife film festivals, personnel wanted, equipment for sale, new productions, training opportunities, films winning awards and so on.

To subscribe – visit www.wildlife-film.com (see below) and enter your email address on the 'Newsletter' page. Here you can also access all previous issues of the e-zine.

www.wildlife-film.com is the parent website of Wildlife Film News. It is *the* international independent website for wildlife film-makers. The site contains directories of producers, festivals, training opportunities, stock footage libraries, location managers, organisations, publications and freelance personnel. If you are looking for, or offering, work in the field of wildlife film-making you can be listed in an appropriate directory on the site.

Wildeye – Wildlife Film-makers' Training – runs a number of courses, workshops and training expeditions for aspiring wildlife film-makers and enthusiastic amateurs. If you are just starting out we suggest you begin with the 'Introduction to Wildlife Film-making' weekend in Norfolk, UK. From there you can go on to take more specialist weekend courses such as editing, sound recording or camera work, or go on one of the experience trips such as the Big Cat Film Safari in Kenya or Bimini Shark Encounter in The Bahamas.
See the website for full details of courses and training expeditions.
Website: www.wildeye.co.uk Email: info@wildeye.co.uk

Wildlife Film Academy (WFA) in South Africa was set up by award-winning wildlife filmmakers and naturalists. They are committed to imparting the skills needed to make innovative wildlife films. The course, hosted in Cape Town (RSA), includes modules on: project conceptualisation, wildlife ethics, pre- and post-production, camera technology and the wildlife filmmaking business. The four-week course includes a week in one of southern Africa's premier wildlife reserves where each student will shoot enough footage to produce a broadcast-quality five-minute short of their own. WFA endeavours to inspire its students to combine technical skill, ecology, ethics in nature, and business savvy to create unique wildlife films.
Website: www.wildlifefilmacademy.com

Wildlife Television Training – Wildlife/Environment, Film/TV/Video
Adult Education Courses taught by Jeffery Boswall. Programme-making production courses for intending and existing practitioners. To inspire new-comers and refresh older-comers. Jeffery was the longest-serving producer in the BBC's Natural History Unit, Bristol; then Head of Film and Video at the Royal Society for the Protection of Birds, before moving to the University of Derby as Senior Lecturer in Wildlife Television.
Website: www.wildlifetelevisiontraining.com

Filmmakers for Conservation (FFC) – "Using the Power of Film and Media to Conserve our Natural World". The mission of Filmmakers for Conservation is to promote global conservation through the making, broadcasting and distribution of films, and to help conservation organisations and filmmakers worldwide produce a greater number of better-informed and more effective conservation films. It is often said that conservation films don't make a difference – Filmmakers for Conservation dispels that myth.
Website:www.filmmakersforconservation.org
Email: paulm@filmmakersforconservation.org

Brock Initiative – Richard Brock worked in the BBC Natural History Unit for 35 years producing, among others, the highly successful *Life on Earth* and *Living Planet* series. Concerned by the lack of willingness to address the real current state of the environment he left the BBC and started his own independent production company, Living Planet Productions.

"These days it's simply not good enough to use the old response ... "If people know about it they'll care for it and do something". Wrong. They'll just go on being conned that it's all perfect out there, with endless jungles, immaculate Masai Maras, and untouched oceans. What planet are they on about?" Richard Brock

Living Planet Productions has made over a hundred films on a wide range of environmental topics, shown all over the world. As his archive of films and footage mounted up, Richard felt that there was something more, better, that could be done with this resource.

"When you consider the miles of footage and thousands of programmes sitting in vaults out there unused, it seems tragic that the very wonders they celebrate are dwindling, often because no one tells the locals and tries to help. That is why I believe it's Payback Time for wildlife television."

He decided to set up the Brock Initiative, to use his archive of footage, and to ask others to do the same, to create new programmes, not made for a general TV audience, but made for those who are really connected to the situation in hand: local communities, decision makers, even that one fisherman who uses dynamite fishing over that one coral reef. It's about reaching those who have a direct impact; reaching those who can make the difference.

Website: www.brockinitiative.org

The International Association of Wildlife Film-makers (IAWF) was founded in 1982 to encourage communication and co-operation between people who are often isolated in the field. It is an association for professional camera men and women and sound recordists earning most of their income from making wildlife films. Worldwide membership includes many of the leading names in the industry. They provide a friendly forum for sharing technical and contractual problems. Regular meetings are held twice yearly. There are opportunities to meet other members, make friends and discuss problems or interests. For further details contact the IAWF secretary.

Email: iawf@macewen.globalnet.co.uk
Website: www.iawf.org.uk

Wildlife Sound Recording Society (WSRS) welcomes anyone with an interest in wildlife sound or a love of natural history. Members are largely amateurs yet the society is in the forefront of reproducing natural sound, with many hundreds of members' recordings held in the National Sound Archive of the British Library. Among other things members enjoy a Sound Magazine (on CD), field meetings and technical workshops, a journal, newsletters and competitions.
Website: www.wildlife-sound.org

DVuser.co.uk is the UK's most comprehensive free online digital video publication. We also have a free quarterly printed publication of the same name. DVuser is aimed at semi-professionals and professionals alike who shoot on DV, HDV & HD digital formats, be it tape, solid state, disc or otherwise. Each month we add new articles, features, stories, tutorials, expert tips, news & the latest digital video equipment reviews. We also have a competitions section as well as extensive user forums, which makes DVuser the most interactive site in the UK.
Website: www.dvuser.co.uk

Wildsounds – books, equipment and information for wildlife sound recordists.
Website: www.wildsounds.co.uk

Shooting People – set up to be a catalyst for change, growth and innovation in film-making. They aim to do two core things: restore originality and creativity to cinema, and help independent filmmakers find the audiences they deserve. They produce daily email bulletins (one of which is for documentary-makers) you can subscribe to – very useful for making contacts, buying/selling second hand equipment etc.
Website: www.shootingpeople.org

Eco-watch Ltd – founded in 1999 with the aim of bringing wildlife closer to everyone using remote surveillance cameras and novel technologies. The advances in miniature camera technology enabled them to supply simple, safe and effective kits to watch birds and animals at home and at school.
Website: www.eco-watch.com

Wildlife Watching Supplies All you need to get closer to the wildlife: camouflaged clothing and materials, hides, camera supports etc.
Website : www.wildlifewatchingsupplies.co.uk

Production Gear – a UK-based company supplying a concise range of broadcast and professional production equipment, ranging from a roll of gaffa tape through to a complete studio.
Website : www.productiongear.co.uk

Travelpharm.com – providing travellers with a range of medication and equipment at competitive prices to make their journey both healthier and safer.
Website: www.travelpharm.com

The Wildlife Trusts is a partnership of 47 local Wildlife Trusts across the UK, plus the Isle of Man and Alderney. They can help with advice on species to be found at their reserves, which may be target species for your film. Their vision is 'an environment rich in wildlife for everyone' and they are the largest UK charity exclusively dedicated to conserving all our habitats and species, with a membership of more than 600,000 people including 100,000 junior members. They campaign for the protection of wildlife and invest in the future by helping people of all ages to gain a greater appreciation and understanding of wildlife. Collectively, they also manage more than 2,500 nature reserves spanning over 80,000 hectares. The Wildlife Trusts also lobby for better protection of the UK's natural heritage and are dedicated to protecting wildlife for the future. Website: www.wildlifetrusts.org

British Trust for Conservation Volunteers (BTCV) – practical conservation fun and activities for you to join in with across the UK. Some of their projects would make interesting subjects for a film. Website:.www.btcv.org

Earthwatch Institute – this international non-profit organisation places paying volunteers of all ages on short-term research expeditions worldwide. Documenting an expedition could form the basis of a film.
Website: www.earthwatch.org

British Big Cat Society (BBCS) – the society was set up to identify, quantify, and scientifically catalogue and protect the big cats that freely roam the British countryside. It is a UK network of people whose aim is to research, study and analyse the presence of big cats throughout Britain. Another major focus will be to educate the public about big cats in general and also more specifically about the ones we believe are present in the UK. Website: www.britishbigcats.com

Wild Boar in Britain – the first UK web-site devoted solely to the interests of free-living wild boar in Britain. The site has been created to increase awareness and understanding of this tremendously interesting animal. Everyone will be catered for, from scientists, conservationists, ecologists, historians, hunters, farmers and interested members of the public. They aim to be non-judgmental and non-moralistic, but simply to report factually on all the issues surrounding a returning wild boar population. The main aim is to provide information on the animals living wild in Britain but also to be a reference point for those with an interest in studying wild boar.

Website: www.britishwildboar.org.uk

Further Reading

Careers in Wildlife Film-making by Piers Warren –
published 2002, 2006 by Wildeye.

This book is the ONLY guide to working in the wildlife film-
making industry. Available mail-order worldwide – this is an
international book featuring many case-studies from all over the
world – successful professionals explain how they got started
and give hard-won advice. Contents include: How Wildlife Films
are Made, The Variety of Jobs, How to Get Started, Education
and Training, Wildlife Film Festivals, Organisations, Projects
and Further Information, The Future of the Industry. The
incredible amount of advice, together with information on
festivals, schools and industry organisations, make this book an
invaluable resource for all those wishing to succeed as a wildlife
film-maker. Online ordering from: www.wildlifefilmcareers.com
which also describes the contents of the book in more detail.

Wildlife Films by Derek Bousé – published 2000 by
University of Pennsylvania Press.

There are few books about wildlife films and this one is certainly
unique. I was surprised by the depth of the scholarly analysis of
wildlife films yet this is not a dry read – in particular the history
of wildlife film-making over the last few hundred years was
fascinating, and the book is littered with behind-the-scenes
anecdotes. Although the book focuses on the industry in the USA
and UK, the discussions (to what extent are wildlife films
documentaries, for example) are applicable to wildlife film
makers the world over. There are so many well-known names –
both companies and individuals – in the business today, and it's
hard to keep track as units change name, merge or disappear.
This book certainly helps piece the jigsaw together as the genre's
development is analysed.

Reel Nature: America's Romance with Wildlife on Film
by Gregg Mitman – published 1999 by Harvard University Press.

Americans have had a long-standing love affair with the wilderness. As cities grew and frontiers disappeared, film emerged to feed an insatiable curiosity about wildlife. The camera promised to bring us into contact with the animal world, undetected and unarmed. Yet the camera's penetration of this world has inevitably brought human artifice and technology into the picture as well.

Gregg Mitman shows how our cultural values, scientific needs, and new technologies produced the images that have shaped our contemporary view of wildlife. Like the museum and the zoo, the nature film sought to recreate the experience of unspoiled nature while appealing to a popular audience, through a blend of scientific research and commercial promotion, education and entertainment, authenticity and artifice. This book reveals the shifting conventions of nature films and their enormous impact on our perceptions of, and politics about, the environment. Whether crafted to elicit thrills or to educate audiences about the real-life drama of threatened wildlife, nature films then and now reveal much about the yearnings of Americans to be close to nature and yet distinctly apart.

Recording Natural History Sounds by Richard Margoschis – published 1977 by Print & Press.

A guide to the techniques of recording wildlife sounds by one of the founders of the Wildlife Sound Recording Society. Although the equipment described in the book is dated many of the techniques are still valid today.

Bill Oddie's How to Watch Wildlife by Bill Oddie, Stephen Moss, Fiona Pitcher – published 2005 by Collins.

A tie-in to the TV series, offering practical advice to beginners wanting to learn more about wildlife, *Bill Oddie's How to Watch Wildlife* is a practical beginner's guide to enjoying the wildlife of Britain. Organised into a calendar of months, it tells you the best places to visit, how to catch a glimpse of our best-loved species, and things you can do for each month of the year. For example in May you could visit some wild flower meadows which are in their prime, see a nightingale, and experience the dawn chorus. Written in Bill's endearingly frank and witty style, this is an inspiring and refreshingly straightforward approach to watching wildlife.

There are suggestions for places to visit within reach of wherever you live in Britain, and advice on watching wildlife with children. With stories of Bill's experiences in the field, it offers you and your family the know-how to start out with confidence. Bill Oddie sets out to demystify wildlife watching, giving advice on basic equipment and fieldcraft, as well as explaining how to make the most of your encounters with animals. To guide you successfully through some of the finest wildlife experiences, there are top tips, advice for things to take with you that you might never have considered, and helpful addresses and websites for some of the activities less close to home. And in case you really get bitten by the bug, there is information on taking the next step, with hints on getting more advanced equipment, which conservation trusts to join, and wildlife holidays to make the most of your new-found skills.

A Life on the Wild Side by Colin Willock – published 2002 by The World Pheasant Association.

Over nearly thirty years Colin Willock wrote and produced more than four hundred films in Anglia Television's famous wildlife series *Survival*. His work took him to some of the wildest places on earth, from the Arctic to the Antarctic. It also brought him

the close companionship of some of the wildest – wild in the sense that they were in tune with nature – people on earth: wildlife cameramen, scientists, park wardens and rangers, animal catchers, bush pilots and eccentrics of the stature that only big, wild country can produce. *A Life on the Wild Side* is a story about the fun of wildlife film-making and the behind-the-scenes adventures that never reached the television screen – sometimes dangerous adventures, hilarious adventures, moving experiences and tragedies too.

In the Heart of the Amazon by Nick Gordon – published by Metro Publishing 2002.

This book is a gripping true-life adventure story, written by the late Nick Gordon about his stint in the Amazon (over ten years) making wildlife films – mostly for *Survival*. I know it's a cliché but I just couldn't put the book down! It reminded me of reading Gerald Durrell's books of natural adventure as a child – books which inspired me to want an adventurous life for myself. Parts of it will make you envious, parts will make you glad it didn't happen to you! It is also an excellent portrayal of the life of a wildlife cameraman in a tropical rainforest, with many examples of the trouble taken to achieve certain sequences that may last only a few seconds on the final film.

Snarl for the Camera: Memoirs of a Wildlife Cameraman by James Gray – published 2004 by Portrait.

James Gray has fulfilled his childhood dream of becoming a natural history cameraman. Over the years he has filmed everything from human lice (which he had to feed on his own blood) to polar bears in the Arctic, anacondas in Venezuela, gorillas in Rwanda, caimans in South America, elephants in Thailand and pandas in China. In this biography he describes his (sometimes very scary) experiences filming wild animals – and introduces readers to some of the tricks of the trade. Keeping the television producers happy requires not only an inordinate

amount of patience and perseverance, wading through swamps and squatting in trees for days – but may also require giving nature a helping hand.

Life On Air by David Attenborough – published 2002 by BBC Consumer Publishing.

Sir David Attenborough is Britain's best-known natural history film-maker. His career as a naturalist and broadcaster has spanned nearly five decades and there are very few places on the globe that he has not visited. In this volume of memoirs David tells stories of the people and animals he has met and the places he has visited. Over the last 25 years he has established himself as the world's leading Natural History programme maker with several landmark BBC series, including *Life on Earth* (1979), *The Living Planet* (1984), *The Trials of Life* (1990), *The Private Life of Plants* (1995), *Life of Birds* (1998), *Life in the Undergrowth* (2005).

True to Nature: Christopher Parsons Looks Back on 25 Years of Wild Life Filming with the BBC Natural History Unit by Christopher Parsons – published 1982 by HarperCollins.

The former head of the BBC Natural History Unit explains how documentaries are made and discusses the interesting people and animals he has encountered. A fascinating history of the first years of the BBC NHU.

BBC Wildlife Magazine

BBC Wildlife magazine not only has the best and most informative writing of any consumer magazine in its field but is also accompanied by the world's best wildlife photographs. If you are looking for inspiration and ideas, *BBC Wildlife* is the ideal information source for new contacts, new discoveries, new stories, new locations and the latest views and news on wildlife, conservation and environmental issues. It also has the only monthly guide to wildlife TV and radio on all channels, accompanied by stimulating previews.

To subscribe at a special price go to
www.wildeye.co.uk/bbcwildlife.htm

About the Author

Piers Warren is well known throughout the wildlife film-making industry as the editor of Wildlife Film News and producer of wildlife-film.com. After a period as a science teacher he entered the media-world as a musician and sound engineer, eventually running his own recording studio.

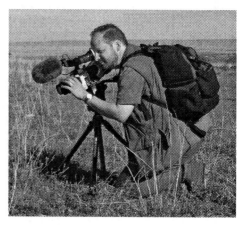

Although he has experience in many aspects of film-making he specialised in multimedia productions through his company, Wildeye, before concentrating on training. He has written several books, including *Careers in Wildlife Film-making*, many magazine articles, and has been a final judge at several wildlife film festivals.

With a strong background in biology, education and conservation, he has had a lifelong passion for wildlife films and has a wide knowledge of natural history. He is one of the founders of the international organisation Filmmakers for Conservation and was Vice President for the first three years.

Wildeye provides independent specialist training for aspiring wildlife film-makers. Through Wildeye, Piers leads wildlife tours and training expeditions around the world.

Printed in the United Kingdom
by Lightning Source UK Ltd.
110551UKS00001B/64-153